# CONVERSATIONS WITH...
## VAN GOGH

# CONVERSATIONS WITH...
# VAN GOGH

## VINCENT VAN GOGH
## & SIMON PARKE

**Conversations with... Vincent van Gogh**

White Crow Books is an imprint of
White Crow Productions Ltd
PO Box 1013
Guildford GU1 9EJ

www.whitecrowbooks.com

Text design and eBook production by Essential Works
www.essentialworks.co.uk

Hardback ISBN 978-1-907661-30-3
Paperback ISBN 978-1-907355-95-0
eBook ISBN 978-1-907355-96-7
Audiobook ISBN 978-1-907355-97-4

Religion & Spirituality

Distributed in the UK by
Lightning Source Ltd.
Chapter House
Pitfield
Kiln Farm
Milton Keynes MK11 3LW

Distributed in the USA by
Lightning Source Inc.
246 Heil Quaker Boulevard
LaVergne
Tennessee 37086

# Contents

# Preface

The conversation presented here is imagined; but Van Gogh's words are not. All of the words included are his own, taken from his extensive – not to say remarkable – letter-writing.

The only alteration to his original words has been the occasional addition of a link word to help the flow. But no phrase is altered, and additions are rare indeed, never affecting either mood or meaning.

After all, to discover the man and his meaning is the reason for this adventure. So this is original Vincent van Gogh; his phrases, expressions, thoughts and feelings.

Yes, even the description of the carpenter who withheld information, and the Anglo-Saxon comments on the sex life of Rubens...

# Introduction

As an up-and-coming artist, the Dutch painter Vincent van Gogh has allowed me to visit him in Auvers, to talk about his life thus far. The respected art critic Aurier recently wrote of him in very favourable terms; and though I hadn't myself heard of him, if he is to become famous, I want to get in before the others.

By way of preparation, I've done my research, talking with various people who've met him. When in Paris, I spoke with two artists who knew him there, and they gave me their impressions: 'Red-haired with a goatee, shaven skull, eagle eye and incisive mouth,' said young Émile Bernard, painter and writer. 'Medium height, stocky without being in the least fat; lively gestures, perky step and with his everlasting pipe, canvas, engraving or sketch. He was vehement in speech, interminable in explaining and developing his ideas, but not very ready to argue.'

I wondered what I was in for, and A. S. Hartrick, another painter, scarcely reassured me. 'He had an extraordinary way of pouring out sentences in Dutch, French and English,' Hartrick recalled. 'Then glancing back over his shoulder, and hissing through his teeth. In fact, while thus excited, he looked more than a little mad; though at other times, he was apt to be morose, as if suspicious.'

Most crucially, however, I spent time with Theo, Vincent's younger brother. These two have shared a close relationship – even if things presently are a little tense. It's Theo who's enabled Vincent to paint, giving endless financial support. In Paris, I heard the art dealer Père Tanguy may have sold one of Vincent's paintings – but no one was very sure. And whether he did, or he didn't, it makes little difference. Vincent has lived off Theo.

I was helped in my preparation by reading some of the

lively correspondence that has passed between these two brothers down the years. And it was also in Theo's company that I pieced together Vincent's nomadic life, from his upbringing in Zundert, Holland, to time spent in the Hague, London, Nuenen, Brussels, Drenthe, Antwerp, Paris, Arles, the asylum of St Rémy and now Auvers-sur-Oise.

And the man himself? Speak to anyone who knows Vincent, and you hear of an eccentric, who makes 'a queer impression' on people and proves demanding, often infuriating, company. Gauguin, who shared a house with him in Arles, remarked that 'it appears there are two different beings in him: the one marvellously gifted, fine and delicate, and the other selfish and heartless.' While Theo himself does not have happy memories of the time they shared a flat in Paris. As he said to me: 'It is a pity Vincent is his own enemy, for he makes life difficult not only for others but also for himself.'

Both endearing and intolerable – this is what people say about Vincent van Gogh. He could be charming and jovial when happy; but tedious in making his point; and unable to let it rest or handle disagreement. Vincent doesn't disagree with such observations, referring to himself as 'a rare specimen out of a collection of freaks.'

So I was prepared for the worst. But on arriving in Auvers, my first impressions are a little different. On meeting Mr Van Gogh, I encounter a man who appears humble, hard-working, ascetic and reticent. Physically, he is sinewy, muscular and restless, with a body harassed by his mind into action. I witnessed this energy powerfully driving the brush work. Here were no delicate watercolours, but exhausting and sweaty endeavours, ripped from his soul!

Concerning clothes, he 'dresses down' as they say. When working for Goupil the art dealers in his early twenties, Vincent was a businessman with a top hat; and a shining example of Dutch cleanliness. But this trait was lost, never to return, when

he went to work amongst the poor in the Borinage, a mining district of Belgium. I'm told that since then, he has cultivated the peasant look, and now regards soap as a disgraceful luxury; an attitude not without consequences, for those who happen to stand too close.

He is endlessly self-critical, I do notice that; and forever declaring himself worthless. But when happy and buoyed up by favourable circumstances, whether inner or outer, he can see the gift he has – so evident in the paintings that surround me here in his lodgings. On one occasion, he even points to a portrait of a woman and tells me 'One day, that will hang in the Louvre!' As you will see, he is a bit up and down.

In short, the more I hear of Vincent – the name by which he insists on being addressed – the more I feel that his life and character are almost as gripping as his pictures. So I look forward to discovering more, as I sit down for conversations with the aspiring painter Vincent van Gogh.

# Auvers and the wheat fields

*Vincent van Gogh has come to live in Auvers, after spending time in the St Rémy mental asylum. Previous to that, he lived in the Yellow House in Arles.*

*We talk in a room crowded with his pictures. Like many aspiring artists, he's struggled to find interest amongst art dealers and buyers.*

*He lives in a disciplined manner. He goes out to paint at 9.00am, after breakfast, returning at noon for lunch. In the afternoon, he either works in his Painter's Room on paintings already started – or he goes out again, and paints until the evening meal.*

*Yesterday, he painted the 13-year-old Adeline Ravoux. She is the landlady's daughter. Vincent completed the portrait in one sitting, and it's a study in blue – though this morning when we met on the stairs, Adeline told me she doesn't like it very much.*

*Apart from the paintings, there is a distinct lack of furniture which I raise with him; and discover it's a sore point.*

v: I am beginning to think I must consider my furniture lost.

sp: But surely it's on its way from Arles?

v: My friends whom it is with, will not, so far as I can see, put themselves out to send it to me, as I am no longer there.

sp: Why not?

v: This is mostly the traditional laziness and the old traditional story, that passing strangers leave temporary furniture in the place where it is. It's bad manners, but what can you do?

sp: Is that a 'South of France' thing?

v: It's not quite the same in the South as in the North, no. The people there do what they like, and don't take the trouble to think of others if they are not there.

sp: Out of sight, out of mind.

v: And of course they do not like to be mixed up any further in this business, which has been much talked of in Arles.

sp: The unfortunate incident with your ear, yes; and no doubt we'll get to that. But on a brighter note, Vincent, let me say straight away how wonderful it is to be surrounded by your paintings. Is there such a thing as an ideal background for them – apart from a rich man's lounge?!

v: My painting is to be seen above all against a simple background. I try to paint it in such a way it looks good in a kitchen. Then sometimes I notice it looks good in a drawing room too.

sp: And here is a self-portrait of yours. So perhaps at the start of our time together, could you talk us through it? Describe yourself?

v: I hate speaking about myself, and I have no idea why I do it. Perhaps I do it in order to answer your questions.

SP: Perhaps it helps you to see what you've found to be true.

V: You see what I have found – my work! And you see too what I have not found – all the rest that belongs to life.

SP: You just paint?

V: A painting machine, that's right, unfit for and uninterested in anything else. I am now in the same mess as in the past.

SP: I'd still like you to describe this self-portrait.

V: A pink-grey face, with green eyes, ash-coloured hair, wrinkles in forehead and around the mouth, stiffly wooden, a very red beard, quite unkempt and sad, but the lips are full, and a blue smock of course linen.

SP: You like blue; I've noticed.

V: You'll say that this is something like the face of death – oh, it isn't easy to paint oneself! In any event, something different from a photograph.

SP: Oh definitely, yes. I don't think the photograph will ever replace the painted portrait.

V: And you see, this is what Impressionism has over the rest.

SP: What's that?

V: It isn't banal, and one seeks a deeper likeness than that of the photographer; the proud photographer with his black shadows!

sp: So that was you a few years ago. What about you now?

v: Yes, I look different nowadays, in so far as I have neither hair nor beard, both being always shaved close.

sp: More like a Buddhist monk.

v: Having had all my beard carefully shaved off, I believe I am both the placid abbot and the mad painter.

sp: Interesting combination. Better than being a mad abbot or a placid painter.

v: I'm not unhappy to be somewhere between the two, because you have to live!

sp: Your complexion has changed over the years.

v: My complexion has changed from green-grey to grey-orange and I have a white suit instead of a blue one, and am always dusty, and always laden like a porcupine with sticks, easel, canvas and other merchandise.

sp: So does anything remain of the old Vincent van Gogh?

v: Only the green eyes have remained the same.

sp: And the same adventurous spirit?

v: I am not an adventurer by choice, but by fate, and feeling never so much a stranger as in my family and country.

sp: That's hard.

v: I consciously chose the dog's path through life, you see – a path on which it is better to be a sheep than a wolf; better to be slain than to slay; better to be Abel than Cain and better to be ruined than to do the ruining. I shall be poor; I shall be a painter.

sp: But you still wish to be appreciated?

v: Oh yes, it does me so much good when people are enjoying my work a bit. For it is so discouraging and dispiriting and acts like, well, a dampener, when one never hears that this or that is right and full of sentiment and character.

sp: The world of art is not an affirming place; not full of hugs and kisses and kind words?

v: Affirming? Art is a jealous world and demands all our time, all our strength, and then, when you've given it that, you're made out to be a sort of impractical type, and I don't know what else; that leaves a bitter taste.

sp: How do you mean?

v: 'Do you imagine such drawings have the least commercial value?' Reprimands like that! Well, we must keep hacking our way through.

sp: The dealers, of course, say the painters don't know that they're born.

v: I really don't know whether to laugh or cry at this sort of thing. I find it so typical. Of course, all rich dealers are good, honest, loyal and sensitive characters.

sp: Do I detect sarcasm?

v: And we poor devils who sit there drawing, whether out
of doors, on the street, in the studio, sometimes early in the
morning, sometimes deep into the night, sometimes in the
heat of the sun, sometimes in the snow – are those with no
understanding of practical matters, and without 'manners' at
all. Fine by me!

sp: It doesn't sound fine.

v: These people begin so kindly and manage to be so winning
at first, that you're all the more amazed when you eventually
see their true colours.

sp: Well, predictably I suppose, I do want to ask you about
colour; the colour you use in your work. You're gaining quite
a reputation in that department. But having spoken with your
younger brother Theo, I gather things are a little tense between
you at present.

v: I would have been absolutely cut off from the world apart
from Theo; he is my friend more than my brother.

sp: Indeed; though there's difficulty now, and things have not
always been harmonious in the past. He didn't always write
when you wished to hear from him, and things turned nasty
once or twice.

v: I said, 'Let's be careful; let's not spin our thread too fine.
You know, it could become too fragile!'

sp: So what were you thinking?

v: Why doesn't he write? If he was afraid of compromising himself at work by keeping in touch with me, was his position in regard to his employers so unsteady and shaky that he would be obliged to be as chary of himself as that? And if he was afraid of compromising himself in one way or another, why not warn me with a brief line and I wouldn't write to him. But in the mean time, I didn't know where to stand or turn!

sp: So you got on with your assumptions.

v: Or was it because he was afraid that I would ask him for money? But then, if that was the reason for his silence, he could at least have waited to be silent at the time when somebody tried to squeeze something out of him, as the saying goes.

sp: But as it turned out, your busy brain was wrong. This was all unverified, all assumption, all in your imagination.

v: I replied at a bad time, I grant you. My drawings weren't going well, and not knowing which way to turn, I began to write.

sp: And it all spilled out.

v: I would certainly have done better to have waited for a better moment, but I belong to that class of persons who don't always think about what they're saying or doing.

sp: And yet, despite it all, you are painting more than ever here in Auvers.

v: Auvers is really beautiful – among other things, there are many old thatched roofs, which are becoming rare. It's the

heart of the countryside, distinctive and picturesque.

s p: And that was Dr Gachet at the door just now. You must have made a friend.

v: I've found in Dr Gachet a ready-made friend, and something like a new brother would be, so much do we resemble each other physically and morally too. He's very nervous and very bizarre himself, and I did his portrait the other day. He lost his wife a few years ago, which greatly contributed to breaking him. I spend one or two days a week working in his garden.

s p: But more than a gardener, you're a painter.

v: Oh yes. Dr Gachet is decidedly enthusiastic about my latest portrait of the Arlésiennes. What I'm most passionate about is the portrait, the modern portrait. I would like to do portraits which look like apparitions to people a century later; not photographic resemblance, but passionate expressions.

s p: But the pictures around me here are not so much portraits as landscapes – work in progress.

v: Here are vast fields of wheat, under troubled skies.

s p: Yes, and not the happiest of images.

v: I do not need to go out of my way to try and express sadness and extreme loneliness.

s p: Tell me about the wheat field.

v: I'm presently absorbed in the wheat fields against the hills,

large as a sea; delicate yellow, delicate pale green, delicate purple of a ploughed and weeded piece of land, regularly speckled with the green of flowering potato plants, all under a sky with delicate blue, white, pink, violet tones. I'm wholly in a mood of almost too much calm to paint that. I must get out to work.

SP: Of course. We'll speak later. I want to hear all about your life!

# Van Gogh, schoolteacher

*I've discovered that Vincent was an unpaid junior master at a dubious private school in the seaside town of Ramsgate, in England. This was after he was sacked by the art dealers, and waiting to be a Christian missionary in London.*

SP: In your early twenties, you were a schoolteacher in Ramsgate, where you taught French. Any memories?

V: The headmaster was Mr Stokes.

SP: A good man?

V: He was rather a large man with a bald head and whiskers. The boys seemed to respect him, yet love him all the same. He was already playing marbles with them just a couple of hours after returning at the beginning of term!

SP: And the boys were treated well?

V: Mr Stokes was sometimes very moody, and when the boys were too boisterous for him, it sometimes happened that they didn't get bread and tea in the evening.

SP: Seems a bit harsh.

V: Oh yes. You should have seen them then, standing at the window looking out. It was really rather sad.

SP: I can imagine.

v: They really had so little apart from their food and drink
to look forward to, and to get them through the day. I'd like
you to have seen them going down the dark stairs and small
corridor to table!

sp: The dining room?

v: On that room, however, the friendly sun shone.

sp: I'm relieved. But the premises left a little to be desired?

v: Another extraordinary place was the room with the rotten
floor, where there were six basins at which they washed
themselves; and with only a feeble light falling onto the
washstand, through a window with broken panes. It was quite
a melancholy sight to be sure. How I'd like to have spent a
winter with them, to know what it was like.

sp: These children were borders?

v: Yes, and I remember the window where the boys stood and
watched their parents going back to the station after a visit.
Many a boy would never forget the view from that window.

sp: Feelings of rejection, perhaps. And the local scenery?

v: Let me tell you about a walk we took.

sp: OK.

v: It was to an inlet of the sea, and the road through it led
through the fields of young wheat and along hedgerows of
hawthorn. When we got there, we had on our left, a high steep
wall of sand and stone as high as a two-storey house, on top

of which stood old, gnarled hawthorn bushes. Their black and grey, lichen-covered stems and branches had all been bent to the same side by the wind.

SP: Sounds bracing.

V: The ground was completely covered by large grey stones, chalk and shells. To the right, the sea as calm as a pond, reflecting the delicate grey sky where the sun was setting. It was ebb tide and the water was very low.

SP: You describe it like a painting. And as I understand it, when you left Ramsgate to seek a church appointment in London, you walked all the way. That's over 90 miles!

V: That was a long walk indeed, and when I left Ramsgate it was very hot and it remained so until evening when I arrived at Canterbury.

SP: A good place for a pilgrim.

V: That same evening I walked a bit further, until I came to a couple of large beeches and elms next to a small pond, where I rested for a while. In the morning, at half past three –

SP: Half past three? You didn't sleep in the –

V: Well, the birds began to sing on seeing the morning twilight, and I continued on my way.

SP: Stiff?

V: No, it was good to walk then. In the afternoon I arrived at Chatham, where in the distance, past partly flooded low-lying

meadows, with elms here and there, one sees the Thames full of ships. It's always grey weather there, I think –

SP: So I hear –

V: – and then I met a cart which brought me a couple of miles further, but then the driver went into an inn and I thought he might stay there a long time –

SP: You were impatient to get on; story of your life, Vincent!

V: So I walked on and arrived towards evening in the well-known suburbs of London. I stayed in London for two days.

SP: I imagine you needed a rest.

V: No – I often ran from one end of the city to the other to see various people, including a minister. I spent one night at Mr Reid's, and the next at Mr Gladwell's, where they were very kind. Mr Gladwell kissed me goodnight and that did me good. I had wanted to leave for Welwyn that evening –

SP: Where your sister was?

V: But they literally held me back by force, because of the pouring rain. However, when it had let up somewhat, around 4 in the morning –

SP: Another early start –

V: I set out for Welwyn, and in the afternoon at five, I was with my sister.

SP: And you saw these people because you wanted to be

a missionary in London.

v: Being a missionary in London was rather special, I believed. One had to go around among the workers and the poor spreading God's word and, if one had some experience, speak to them, track down and seek to help foreigners looking for work, or other people who were in some sort of difficulty.

sp: And this suited you?

v: I spoke various languages, and had tended to associate, in Paris and London, with people from the poorer classes and foreigners, and being a foreigner myself, I thought myself suited to this, yes.

sp: But you didn't become a missioner.

v: One had to be 24 years old, so I still had a year to wait.

sp: And in the meantime, you linked up again with the dubious Mr Stokes, who had now moved his school from Ramsgate to Isleworth in West London. But he still wouldn't pay you.

v: He couldn't give me a salary at first, for he said he could get plenty of people who'd work for board and lodging alone, which was certainly true.

sp: Were the new premises an improvement?

v: There were lots of bed bugs at Mr Stokes, but that view from the school window made one forget them.

sp: And what did Vincent the Schoolmaster's day look like?

v: Every day I taught them biblical history and that was something more than a pleasure. But in the evenings, I often told stories such as Andersen's fairy tales, and sometimes something from Dutch history, too. When I finished my evening stories, they'd all have fallen asleep unnoticed. It was no wonder really, because they ran around a lot in the playground.

s p: But you could communicate?

v: I spoke with some difficulty and I don't know what it sounded like to English ears. I felt the Lord received me just as I was – though there was an even deeper kind of receiving for which I hoped.

s p: You wanted the love of a woman?

# *The lights of London*

SP: Your first experience of London had been when you worked for Goupil the art dealers. They sent you from their Hague branch to their London branch.

V: Yes, and I can't tell you how interesting it was to see London; the trade and way of life there, which were so different from ours – even though it wasn't as exciting as the Hague branch.

SP: And initially, they were happy days with the company.

V: I walked as much as I could, but I was very busy. It was absolutely beautiful, even though it was in the city. There were lilacs and hawthorns and laburnums blossoming in all the gardens, and the chestnut trees were magnificent. If one truly loves nature, one finds beauty everywhere. So I enjoyed the walk from home to the office, and in the evening, from the office back home. It took about three quarters of an hour.

SP: Isn't that a picture of London in the corner? It looks to be an early one; very early.

V: Yes, I made it one Sunday, when the daughter of my landlady died, aged 13. She died of pneumonia. It's a view of Streatham Common, large grass-covered area with oak trees and broom. It had rained in the night, and the ground was soggy here and there, and the young spring grass fresh and green.

SP: So is it your first ever picture?

v: I sometimes made sketches as a boy

sp: Of course. But it does strike me that there was a rather wonderful energy in you at this time; the energy of an adventurer. What were you thinking?

v: I was thinking 'How could I be useful; of what service could I be?' There was something inside me, what could it be?

sp: You thought it was to be a Christian missionary.

v: I remember regretting not going to hear Moody and Sankey when they were in London.

sp: Ah, the famous Christian evangelists?

v: There was such a yearning for religion among the people in those big cities. Many a worker in a shop or factory had had a remarkably pure, pious youth. City life often took away the 'early dew of the morning' – yet the yearning for the 'old, old story' remained. After all, the bottom of one's heart remains the bottom of one's heart.

sp: True. And you were reading George Eliot at this time.

v: In one of her books, she described the life of factory workers who have joined a small community and hold religious services in a chapel in Lantern Yard. She says it is 'God's kingdom on earth', nothing more, nothing less. And there was something moving about seeing the thousands flocking to hear those evangelists.

sp: What else were you reading?

v: I remember telling Theo that if he could ever get hold of Bunyan's *Pilgrim's Progress*, it was very worthwhile reading. For my part I loved it with heart and soul.

sp: And you saw the sights as well?

v: I went to Hampton Court to see the splendid gardens and long avenues of chestnut and lime trees where masses of crows and rooks have their nests; and also to see the palace and the paintings.

sp: Which ones?

v: There were many portraits by Holbein which were very beautiful, and two beautiful Rembrandts – the portrait of his wife and one of a rabbi. And also beautiful Italian paintings by Bellini, Titian, a painting by Leonardo da Vinci and a beautiful painting by S. Ruysdael.

sp: You'd recommend the place?

v: I couldn't help thinking vividly of the people who had lived at Hampton Court, Charles I and his wife.

sp: Queen Henrietta?

v: She was the one who said, 'I thank thee, God, for having made me queen, though an unhappy queen.'

sp: Perhaps that's how you feel about being a painter. You're glad you're a painter, though an unhappy one.

v: Sorrowful yet always rejoicing! And I remember the sweet violets they sold on the streets of London. I bought

some for Mrs Jones.

s p: You left Mr Stokes' school eventually, and went to work in another school for the Rev. Jones – who actually gave you a little money?

v: That's right. And I bought sweet violets for Mrs Jones, the Headmaster's wife, to make up for the pipe I smoked now and then; mostly late in the evening in the playground.

s p: Winding down after a hard day.

v: The tobacco there was rather strong though.

s p: You and your pipe!

v: Oh, and I remember Acton Green. It was surprisingly muddy, but was a beautiful sight when it began to grow dark, and the mist rose and one saw the light of a small church in the middle of the green. And to the left were railway tracks on a rather high embankment and at that moment a train came, and that was a beautiful sight, the red glow of the locomotive, and the rows of lights inside the carriages in the twilight. To our right, a few horses were grazing in a meadow surrounded by a hedge of hawthorn and blackberry bushes.

s p: It seems you never stopped walking in London.

v: And Hyde Park at 6.30 in the morning! The mist was lying on the grass and the leaves were falling from the trees, and in the distance one saw the shimmering lights of street lamps, that hadn't yet been put out; and the towers of Westminster Abbey and the Houses of Parliament, and the sun rose red in the morning mist.

SP: I'd like to stand where you did.

V: From there, I travelled onto Whitechapel, that poor district of London which Dickens writes of; and then travelled home for part of the way on the underground railway, since I'd received some money from Mr Jones.

SP: Did you have friends in London?

V: The Gladwells were my friends.

SP: You'd known their son Harry when you were in Paris.

V: Yes, and I remember visiting him when he was home for a few days. Something very sad had happened to his family. His sister, a girl full of life, with dark eyes and hair, 17 years old, fell from her horse while riding at Blackheath. She was unconscious when they picked her up, and died five hours later without regaining consciousness.

SP: Tragic.

V: I went there as soon as I heard what had happened. It was a long walk to Lewisham, from one end of London to the other. On my arrival, they had all just come back from the funeral. It was a real house of mourning and it did me good to be there. I had feelings of embarrassment and shame at seeing the deep, estimable grief; for these people were estimable.

SP: And you caught up with your friend Harry.

V: I talked with Harry for a long time, until the evening, about all kinds of things. And we walked up and down on the station, talking; those moments before parting

we'll probably never forget.

SP: You felt close.

V: We knew each other so well. His work was my work, his life was my life and it was given to me to see so deeply into their family affairs, because I loved them. Not so much because I knew the particulars of their family affairs, but because I felt the tone and feeling of their being and life.

SP: You found it hard to say goodbye.

V: We walked back and forth on that station, in that everyday world, but with a feeling that was not everyday.

SP: That's a nice way of putting it.

V: They don't last long, such moments, and we soon had to take leave of each other. It was a beautiful sight looking out from the train over London that lay there in the dark, with St Paul's and other churches in the distance. I stayed in the train until Richmond, then walked along the Thames to Isleworth. That was a lovely walk: on the left, the parks with their tall poplars, oaks and elms; on the right, the river reflecting the tall trees. It was a beautiful solemn evening; I got home at a quarter past ten.

SP: And then life took you back to Holland; but with many memories.

V: I remember looking out of my windows one night, onto the roofs of the houses one sees from there; and the tops of the London elms, dark against the night sky. Above those roofs, one single star; but a nice big friendly one.

SP: You like stars.

V: And I thought of us all – the family, friends – and I thought of the years of my life that had already passed, and of our home, and the words and feeling came to me: 'Keep me from being a son that causes shame. Give me your blessing not because I deserve it, but for my mother's sake. You are love and hear all things. Without your constant blessing we can do nothing.'

SP: A closing prayer, as the curtain closed on London; and rather different adventures beckoned.

# Learning to draw

*We are sitting again in the Painter's Room which his landlady has given him. And I'm gazing around in awe, while Vincent lights his pipe.*

SP: I'd like to paint pictures like these, Vincent, I really would! But I can't. So how do you get to be an artist?

V: What is drawing? How does one get there? It's working one's way through an invisible iron wall that seems to stand between what one feels and what one can do.

SP: So how does one get through that wall? Since hammering on it doesn't help at all.

V: In my view, one must undermine the wall and grind through it slowly.

SP: That sounds like hard work. But you speak also of joy in your art.

V: Oh yes! You must imagine me in Brussels, sitting at my attic window. Over the red tiled roofs comes a flock of white pigeons flying between the black smoking chimneys. But behind this is an infinity of delicate gentle greens; miles and miles of flat meadows, and a grey still sky.

SP: You were in Brussels?

V: In Brussels, I had a model almost every day. A delivery man or some labourer or lad whom I had pose. I liked landscape

very much, but ten times more, these studies of everyday life; sometimes terrifying truthfulness.

SP: But models were expensive.

V: Of course I had to pay the people who posed. Not very much, but because it was an everyday occurrence, it was one more expense, as long as I failed to sell any drawings. But because it was only rarely that a figure was a complete failure, it seemed to me the cost of models would recoup itself fairly soon.

SP: You believed you could make it in the business.

V: Without in any way daring to claim to rise as high as the best, nevertheless, I was confident in succeeding in becoming more or less capable of working in magazine or book illustration. It depended on working hard. 'Not a day without a line,' as Garvani used to say.

SP: But it was demanding.

V: Drawing figures and scenes from everyday life required not only a knowledge of drawing as a craft, but in addition, rigorous study of literature, physiognomy etc – which are difficult to acquire.

SP: And presumably you needed a permanent studio – and costumes for models?

V: This is the only way to succeed, by drawing from a model with the necessary costume. Only if I pursued drawing this thoroughly and seriously, always seeking to portray reality, would I succeed. I knew I also had to make some studies of

the nude one way or another. Not exactly academic poses; but I wanted so very, very much to have a nude model for a digger or a seamstress; from the front, from the back; from the side; to learn to see and to sense the shape through the clothing and to get a clear idea of the movement. The difficulty, though, lay in finding models for the purpose.

sp: There wasn't a queue of people offering to model nude?

v: The fear that 'they have to strip naked' was usually the first scruple to be overcome when approaching someone about posing. I even had this experience with a very old man!

sp: But as you say, you felt there was a living to be made in the business?

v: A good draughtsman could certainly find work. In Paris, there were draughtsmen who earned 15 francs a day, and in London and elsewhere just as much or more. So the thing was to become as good as possible.

sp: And you did want to earn money. Theo was supporting you, but how you longed to be independent. Your finances dominate the letters you wrote to him.

v: Money would not have been disagreeable at all, though the main thing was that I progressed and became better at drawing. Then I felt much would fall into place later on, whether it took time or not. But models were expensive, and if I could have paid them more and used them often, I'd have been able to work much better. A studio then became indispensable.

sp: As were clothes!

v: I bought a pair of trousers and second-hand jacket one month. It turned out so well I bought another pair of trousers and jacket from the same man. I was more or less provided for by the first one, but having two suits is actually better and they don't wear out so fast, because one can alternate between them. And I remember I also needed to supplement my under clothes with three pairs of underwear for which I paid 2.75 francs, and I also bought a pair of shoes for 4 francs.

sp: Such extravagance!

v: I really did have to buy a few things, which made a noticeable hole in what was sent by Ma and Pa that month, and I had to tighten my belt rather, especially as I paid a painter 5 francs in advance for the lessons. So don't suspect me of recklessness, for in fact the opposite is sooner my failing.

sp: You never forget an expense, Vincent, and what with models, studios, underwear and rent – the bills were clearly adding up. And then, of course, you discovered that Theo was sending you money, without you knowing it. How did you respond to your younger brother supporting you?

v: With heartfelt thanks. I said he could have every confidence that he wouldn't regret it; that in this way, I was learning a handicraft, and that although I'd certainly not grow rich by it, at least I'd earn a 100 francs a month necessary to support myself once I was surer of myself as a draughtsman.

sp: That was the plan?

v: The cost of accommodation was at least 100 francs a month. Anything less would have meant suffering deprivation, whether bodily or through a lack of indispensable materials

and tools. 'Poverty prevents good minds succeeding,' said Palissy.

SP: So what were your basic needs?

V: The most necessary things were bread, clothing, rent, models and drawing materials. I didn't desire wealth, but I couldn't stand the thought of not having the most necessary things.

SP: So there you were, eking out an existence, when your family wasn't poor; not at all. Did you have any feelings about that?

V: Of course! How could it be that in a family like mine, I couldn't continue to count in one way or another on those 100 francs a month for the time that must necessarily elapse before I obtained regular employment as a draughtsman?

SP: Your Uncle Cor, a bookseller and art dealer in Amsterdam – he had both money and contacts. Didn't he help out?

V: I'd had words with Uncle Cor a few years before, on an entirely different matter. But was that any reason for him to bear me ill will for ever and ever?

SP: So he didn't help out?

V: I much preferred to assume that he never bore me ill will, and view it as a misunderstanding for which I'd gladly take the entire blame, rather than bickering about whether and to what extent I was to blame – because I had no time for such arguments.

sp: You don't like arguments.

v: Uncle Cor so often did things to help other draughtsmen. So would it have been so very unnatural for him to take an active interest in me as well?

sp: You clashed.

v: I said these things not so much to obtain financial help, but rather because I thought it wouldn't be good if he were to show himself completely unwilling for there to be a vigorous renewal of harmony between us.

sp: So it wasn't just about money.

v: No. He could have helped me a great deal in a wholly different way than by giving me money.

sp: For example?

v: By putting me in touch with people from whom I could learn a great deal.

sp: So you felt unsupported at this time. People, for whatever reason, thought there was something wrong with you. Or at least you thought they thought that.

v: Such experiences are unpleasant to say the least. But with patient energy, I had to try and make progress notwithstanding. I meant to, and where there's a will there's a way. And really, would I be to blame if later on I was to take revenge?

sp: Revenge?

v: But a draughtsman doesn't draw for the sake of revenge. Rather, he draws for the love of drawing; and that's more compelling than any other reason.

sp: You were angry, nevertheless; you felt judged by people.

v: I'd always be judged or talked about in different ways, whether within or outside the family; and I don't blame anyone for it, for relatively few people know why a draughtsman does this or that.

sp: How do you mean?

v: Take peasants and towns people. They generally impute very great wickedness and evil intentions never dreamt of by the one who betakes himself to all manner of places to visit, in order to find picturesque places or figures.

sp: You got comments from people as you went about your work?

v: A peasant who sees me drawing an old tree trunk, and sees me sitting in front of it for hours, thinks I'm mad, and naturally laughs at me.

sp: Thinks you should get a proper job.

v: Or a young lady who turns her nose up at a workman in his patched and dusty and sweaty work clothes, can't understand why anyone visits the Borinage or goes down a coal mine. And she too comes to the conclusion that I'm mad!

sp: That's hard.

v: Of course, all that wouldn't have mattered in the slightest, if only Theo, Mr Tersteeg, Uncle Cor and Pa had known better, and far from criticizing my work, said instead – 'Your line of work involves such things, and we understand why it is so.'

sp: But they didn't; they didn't understand why it was so. And you also felt misunderstood by those who asked if you painted for money.

v: Huh! It's the reasoning of a bloody idiot; that originality should prevent one from making money from one's work! Trying to pass this off as an axiom is a common trick of bloody idiots and idle little Jesuits.

sp: And you heard a lot of it?

v: One heard that drivel day in, day out. One really doesn't give a fig, but it gets on one's nerves all the same – just like listening to off-key singing or being pursued by a malicious barrel organ.

sp: A terrible thought.

v: But don't you find that's the case with barrel organs: that they appear to be picking on you in particular?

sp: Maybe. Though of course Anton Mauve, your first real art teacher, picked on you as well early on; but you didn't mind on that occasion.

v: Mauve? He said to me, 'I always thought you were a bloody bore – but now I see that this isn't so!'

sp: Yes, a rather nice thing to hear.

v: I can assure you, that those plain-spoken words gave me more satisfaction than a whole cartload of Jesuitical compliments would give me.

sp: Mauve was a decent artist himself, of course; I know his work. He stayed Dutch, painting rural scenes with delicate greys and greens, and from the realism school, obviously. But was he a good teacher?

v: He instructed and encouraged me in all manner of kind and practical ways. If he told me this or that wasn't good, he was saying at the same time, 'but try it this way or that way' and that's extremely different from criticizing for the sake of criticizing.

sp: And you felt you were improving?

v: I now considered myself to be at the beginning of the beginning of something serious.

sp: That must have been an exciting moment.

v: And you can't imagine the feeling of relief I get when I remember what Mauve said about the earning of money. Just think how I'd slogged away all those years, always in a kind of false position.

sp: You were a late starter.

v: But now there was a glimmer of real light. I was immersing myself in painting with all my strength; immersing myself in colour.

41

SP: And that was a change, wasn't it, because before 1882, you just did drawings.

V: I'd held back from paint until then, but I don't regret that.

SP: You were learning your craft.

V: With paint, however, I felt I was on the high seas, and that painting should proceed with all the strength I could muster.

SP: Full steam ahead!

V: No turning back, old chap! If boyhood and youth are vanity, must it not be our ambition to become men?

SP: I can feel your excitement. Though I suppose every young painter needs friends in high places – sponsors, patrons or whatever. And Theo always encouraged you to stay friendly with Tersteeg – a man who he says was like a brother to you both.

V: Well, he may have been friendly with Theo, but for years I had been confronted with his hard and unfriendly side.

SP: Cruel to be kind, perhaps?

V: He would have been right in reproaching me if I didn't work, but it was disgraceful to upbraid someone who worked hard, with rebukes such as 'I'm absolutely certain you're no artist,' or, 'For me, it counts heavily against you that you started too late,' or again, 'You have to earn your bread!'

SP: Harsh words – and you reacted badly.

v: I certainly did. I said 'Stop! Easy does it!' One can't always be friends, one must quarrel occasionally. But for half a year, I didn't talk to Tersteeg. I'd prefer to have no midday meal for half a year, and save money like that, rather than receive ten guilders now and then from Tersteeg, along with his reproaches.

sp: He said you should use fewer models.

v: I'd like to know what painters would say to his argument 'take fewer models to economize' – just at the very moment when after much hunting, one has found models who aren't too expensive. Working without a model is the bane of the figure painter, especially at the beginning of his career.

sp: They provide you with energy?

v: As long as I was painting, it was enough for me, but when my models went, a feeling of weakness came over me.

sp: I'm told that's because you weren't eating properly. It was almost as if you were punishing yourself for something. But with Tersteeg pressuring you for more saleable paintings, you did try and oblige.

v: When short of money, I forgot myself for a moment and thought 'I'll simply try and make something that has a certain look'.

sp: Did it work?

v: The result was appalling, I couldn't do it. And Mauve rightly got angry with me and said: 'That's not the way; tear those things up.'

SP: That can't have been easy to hear. After all, you were only trying to survive!

V: At first it sounded too harsh, but later I cut them up myself.

SP: Brave.

V: Then when I started painting more seriously, Tersteeg criticized it again and got angry, and demanded saleable ones straight away. There was a difference between Mauve and Tersteeg.

SP: And of course those were hard financial times for everyone, with the mass strikes.

V: It was certainly gloomy for anyone trying to make a living then, with the working man justifiably against the bourgeois

SP: Though as you know, many said the strikes were worthless.

V: The strikes weren't worthless for later generations, because by then the cause will have been won.

SP: So did you get involved?

V: No. The best thing to do was to keep quiet because the bourgeois didn't have fate on their side; and in the meantime, thousands walked about desolate.

SP: How did you react?

V: I saw, just as clearly as the greatest optimist, the lark ascending in the spring sky. But I also saw the young girl

of barely twenty, who could have been healthy, but had contracted consumption – and perhaps would drown herself before she died of the disease.

sp: You saw the beauty and the pain. But with doors closing, and galleries reporting terrible business, the temptation to give up painting must have been strong. You were surely attempting the impossible?

v: What would life be if we had no courage to attempt anything? If you hear a voice within saying 'You are not a painter' then by all means paint – and that voice will be silenced. Even then, I saw drawings and pictures in the poorest of huts and the dirtiest of corners. By working hard, old man, I hoped to make something good one day. I hadn't got it yet, but I was pursuing it, and fighting for it. I wanted something fresh, something with soul in it. Onward, onward! A good picture is equivalent to a good deed.

sp: Hear, hear! And mistakes are part of the process?

v: Even the knowledge of my own fallibility cannot keep me from making mistakes.

sp: True.

v: But only when I fall, do I get up again. So it is better to be high-spirited even though one does make mistakes; than to be narrow-minded and all too prudent.

sp: No one would call your paintings 'prudent', Vincent. And tell me – did you have a favourite season for painting at that time?

v: I liked autumnal weather then – rainy and chilly, but full of atmosphere. It was especially good for figures, which show a range of tones on the wet streets and roads in which the sky is reflected. Autumn makes nature even more serious and intimate.

sp: This was before you discovered the sun, of course. But in the meantime, the outcast painter was trying to stay healthy. Washing even?

v: I had baths as often as I could, two or three times a week, in the bath house. One gets what they call 'radiation'.

sp: What's that?

v: The pores of the skin stay open, and the skin can breathe, whereas otherwise it shrivels up a bit.

sp: And does this prolong life? I've always felt that when it's time to go, it's time to go. You know what they say – what will be, will be.

v: The Moslem idea that death comes only when it must – well, for my part, I see no evidence of any direct action from above in this matter. On the contrary, I think there is evidence that good hygiene not only prolongs life, but can make it more serene, a clearer stream.

sp: And bad hygiene?

v: Didn't I myself see a very fine man die before my eyes for want of an intelligent doctor? He was so calm and serene throughout, but kept on saying, 'If only I had another doctor.' He died with a shrug of his shoulders

and a look I'll never forget.

SP: Any other health tips – apart from a good doctor?

V: Of course you mustn't be embarrassed about going to see a girl now and then, because for someone whose life is all hard work and exertion, it's necessary, absolutely necessary.

SP: This is for sexual relief?

V: Nature has fixed laws and it's fatal to struggle against them.

SP: And you wanted to live long, and still do; because you are a driven man, and there is much to do.

V: I told my doctor that I knew several painters who, despite all their nerves had reached 60, even 70, fortunately for them; and that I would like to reach that age too; reach the age that's necessary for producing a body of work. And now goodbye for the day.

SP: Yes, goodbye, Vincent. I know you have work to do. I might take a stroll into the village.

V: If anyone should ask after me, bid them good day.

SP: I will, Vincent; I will.

# Leaving my religion

*When in London, Vincent wanted nothing more than to be a Christian missionary; and in the Belgian mining district of the Borinage, he fulfilled his dream, serving the poorest of the poor, in the manner of Christ.*

*On reaching his mid-twenties, however, the tectonic plates within seemed to shift. Something was ending; and something beginning.*

v: For my part, I'm always glad that I've read the Bible, better than many people nowadays, just because it gives me a certain peace that there have been such lofty ideas in the past. But precisely because I think the old is good, I find the new all the more so.

sp: You've continued to paint religious images, sometimes using the motifs of Rembrandt. But it's clear that religious people make you angry.

v: There were some amazing characters in Drenthe. I remember the non-conformist ministers with their pig faces and cocked hats.

sp: You didn't feel warmly towards them.

v: Also many veritable Jews who looked extraordinarily ugly amidst the Millet-esque types. I travelled with a party of Jews who were having theological discussions with a couple of peasants. How are such absurdities possible in a country like this?

SP: Everyone taking religion too seriously?

V: Why can't they look out of the window or smoke pipes?
At least behave as reasonably as their pigs, say, which aren't
any nuisance at all, remaining in harmony with their
surroundings. But before ministers like the ones I saw achieve
the height of civilization and reason of common pigs, they will
have to improve a good deal more.

SP: You don't like clergymen.

V: At the moment, any pig is better to my mind.

SP: And what is their particular failing?

V: There are – a rule with exception – no more faithless and
hardened and worldly people than clergymen and above all,
clergymen's wives.

SP: The wives are worse? But your mother was a clergyman's
wife.

V: Though even clergymen sometimes have a human heart
beneath their armour of triple bronze.

SP: Was that true of your father? You drifted away from
organized religion in your twenties, and he was a church
pastor. How did he react?

V: Whenever I told Pa anything, it was all just idle talk to
him, and certainly no less so to Ma.

SP: You didn't feel listened to?

v: I also found their sermons and ideas about God, people, morality and virtue almost complete nonsense. I read the Bible sometimes, just as I sometimes read Michelet or Balzac or Eliot; but I saw completely different things in the Bible than them.

sp: And this led to rows.

v: Oh yes. I had such a temper – one I cannot remember having in all my life – and I bluntly told Pa that I thought his whole religious thing horrible, and that exactly because I'd studied these things closely during a most miserable episode in my life, I wanted no more to do with it all, and would have to avoid it like a killing thing.

sp: And so given relationships at home, Mauve was something of a relief to be with.

v: Mauve had a refined sensibility and I found that sensibility to be worth so much more than definition and criticism. All that drivel about good and evil, morality and immorality, I actually cared so little about it.

sp: And didn't Mauve indulge in some cruel but amusing impressions?

v: He used to imitate preachers in the pulpits, yes. 'God is almighty!' he said, in the manner of Father Bernhard. 'He created the sea, he created the earth and sky and the stars and the sun and the moon, he can do everything – everything, and yet, no, he's not almighty. There's one thing he cannot do. What is the one thing the almighty cannot do? He cannot cast away a sinner!'

SP: Though you fell out with Mauve at one point. What was that about?

V: He would imitate me.

SP: What, you as well? So the man who did impressions of clergy also did impressions of Vincent van Gogh?

V: He'd say 'That's the face you pull,' or, 'This is how you talk.'

SP: And you didn't like that.

V: My dear fellow, if you had spent nights in the streets of London or cold nights in the Borinage, hungry, roofless, feverish – perhaps you'd also have the occasional ugly tic, or something in your voice to show for it. Though in fact it pleased me very much indeed that a doctor took me for an ordinary workman, and said, 'You must be an iron worker by trade.'

SP: Why did that please you?

V: When I was younger, it could be seen that I over-exerted myself intellectually, but now I looked like a bargee or someone who worked in the iron trade – tough as nails. You see, that's precisely what I'd been trying to change in myself.

SP: You didn't want to be perceived as some effete artist or respectable middle-class; you were working class, at the bottom of the pile, battered by life but fighting on. That was your self-image?

V: That's right.

SP: And meanwhile, back with religion, Theo was quietly declaring himself an unbeliever.

V: He was mistakenly calling himself unbelieving, though perhaps he thought he was a materialist. Even so, he was the first man, if I dared attack him forcefully, who took it well and came back without anger.

SP: By their fruits you shall know them. But you were also brothers in apostasy, and your mother didn't make it easy for you. What was the prayer she used when you left home?

V: 'Father, I pray not that you should take them out of the world, but that you should keep them from evil.'

SP: Ah yes. The prayer Jesus prayed for his followers, before he died.

V: That's right.

SP: And were you kept from evil?

V: What sort of a religion is it that these respectable people subscribe to? They make society into a madhouse; into an upside down wrong world.

SP: You certainly felt that when Margot Begemann tried to commit suicide.

V: Margot.

SP: Have I got this right? She was ten years older than you, and by all accounts, a rather lonely spinster. You became close when she helped look after your mother, and there was even

talk of marriage between you. But you felt everyone around her was bad-mouthing the relationship.

v: In her youth, she had allowed herself to be crushed by disappointments; crushed in the sense that her religious orthodox family thought they had to suppress the active, no, brilliant quality in her.

sp: It sounds like you could see yourself in her.

v: I used to be very passive, soft-hearted and quiet. I'm not anymore.

sp: So another family row. But the relationship with Margot came to an end.

v: I didn't think she would try again; a failed suicide is the best remedy for suicide in the future. But I was so upset by it.

sp: It seems respectability kept thwarting your intentions. Yet as we know, you were full of religion when in London; a great reader of the Bible, a keen listener to sermons and a preacher yourself. Do you now regret that religious phase of your life?

v: If there's anything I regret, it's that for a time I let mystical and theological profundities seduce me into withdrawing too much inside myself. I've gradually stopped doing that. If you wake up in the morning and you're not alone and you see in the twilight a fellow human being, it makes the world so much more agreeable, don't you think? Much more agreeable than the edifying journals and white-washed church walls the clergymen are in love with.

sp: So where is God?

v: God actually begins when we say those words: 'O God, there is no God.'

sp: You're saying goodbye to a particular version of God?

v: I find the clergyman's God dead as a doornail. But does that make me an atheist? I love! And how could I feel I love if I myself weren't alive and others weren't alive? So call it God or human nature or what you will, but there's a certain something I can't define in a system, even though it's very much alive and real; and you see for me, it's God; or just as good as God.

sp: So you believe in love?

v: Look, if I must die in due course, in one way or another, fine – what would there be to keep me alive? Wouldn't it be the thought of love, moral or immoral love – what do I know about it?

sp: And you retain a great love for what you see. Carlyle said that belief should arise from the real world, rather than outworn iconography. And you love the real world; it stirs you.

v: If I am at all capable of spiritual ecstasy, then I feel exalted in the face of truth; of what is possible. I can do very well without God in my life and in my painting, but I cannot – suffering as I am – do without something that is greater than I am, which is my life; the power to create.

sp: And do you find God in other people's paintings?

v: I think that everything that is really good and beautiful – of inner spiritual and sublime beauty – in men and their works

comes from God. If, for instance, someone loves Rembrandt seriously, that man will know there is a God.

SP: And you do love Rembrandt seriously; particularly his portraits, and his painting *The Jewish Bride*.

V: Would you believe it – and I honestly mean what I say – I should be happy to give ten years of my life if I could go on sitting there in front of that picture for a fortnight, with only a crust of dried bread for food.

SP: I think I'd call that an endorsement. And then yesterday, you were telling me that you also find God in maps, which may surprise some – and indeed may be a first! 'Stieler's atlas pointed me towards God,' you said.

V: In Stieler's atlas –

SP: – many are talking about it –

V: – there was a map of the British Isles, and one of England, Scotland (superb) and Ireland separately. Pay attention also to those of Denmark, Sweden, Norway and especially that of Greece. England is a country after God's heart, if one looks at those maps, and one cannot help thinking: God is wise and great, he who has made all that in such a way.

SP: I must get hold of a copy. But despite the maps, what is clear as we talk, Vincent, is your abandonment of all the cultural and moral expectations of your childhood. Do you feel you've lost something?

V: I don't even think whether I've lost or not lost by it. I only know that these forms and notions don't hold water, and are

often even fatal. I came to the conclusion that I didn't know anything, but at the same time, that the life we are in is such a mystery that the system of 'respectability' is certainly too narrow.

SP: Does that leave you looking adrift and aimless in other people's eyes?

V: Yes, people say you lack character if you have no aim, no aspiration.

SP: And your answer?

V: My answer is this: I didn't tell you I had no aim, no aspiration. I just said I found it unspeakably priggish to want to force someone to define what is indefinable.

SP: Fair point. So what guides you now?

V: My own conscience is the compass that shows me the way; although I know that it doesn't work exactly accurately.

SP: No, I think I'd agree there. But tell me – as we sit here now, what do you know?

V: For my part, I know nothing with any certainty; but the sight of the stars makes me dream.

SIX

# *Love in a cold climate*

*Vincent has fallen in love with many women; I haven't quite
discovered how many, but maybe it isn't pressing. First was
Ursula Loyer, the daughter of his landlady in London; but she
was already engaged to another man. And then in Holland, he
proposed to Kee Vos – a widow with a child of eight, who was still
in love with her dead husband. She was emphatic in her answer:
'No, never, no,' she said, words which haunted Vincent for a long
time.*

*Apparently, according to Kee's brother, the basic problem with
Vincent was his lack of money. He just wasn't respectable enough.*

*Vincent has gone on to have many relationships since. The only
unifying theme in the story is that they have all ended unhappily
– so far.*

v: A woman is a totally different being from a man, and a
being we do not know yet; at least only quite superficially.

sp: You think there is a difference between the sexes?

v: If women do not always show in their thoughts the energy
and elasticity of men – who are disposed towards reflection
and analysis – we cannot blame them, at least in my opinion,
because in general they have to spend so much more strength
than we in suffering pain.

sp: They suffer more?

v: They suffer more and are more sensitive. And though they

do not always understand our thoughts, they are sometimes truly capable of understanding when one is good to them.

sp: Well, that's a relief.

v: There is in women sometimes a curious kind of goodness, and a man and a woman can be one.

sp: You want to love; always have done.

v: The way to know life is to love many things. Love many things for therein lies the true strength, and whosoever loves much, performs much, accomplishes much, and what is done in love is done well. I said this to Theo, being friends, being brothers – love, that is what opens the prison.

sp: But love is not without its difficulties.

v: Love always brings difficulties, that is true; but the good side of it is that it gives energy. I feel there is nothing more artistic than to love people.

sp: But they don't always love you back. Your first love was Ursula Loyer – the daughter of your landlady in London.

v: That caused me many years of humiliation; a heavy depression.

sp: But she was already engaged.

v: I regard a 'No, never, no,' as a piece of ice that I press to my heart to thaw. Deciding who will win – the coldness of that piece of ice or my warmth of life – that's a delicate matter.

s p: And then back in Holland you fell for Kee Vos.

v: I just wished that others kept quiet, if they had nothing better to say than 'unthawable', 'madness' and such loving innuendoes.

s p: This was your family disapproving of the match.

v: My family and her father, the Rev Dr Sticker –

s p: – a friend of the family –

v: – well, he became a completely different person if you loved his daughter, than he was before then! He became quite enormous and took on unheard of proportions.

s p: You didn't give up, though, and he had to intervene. What happened?

v: He told me my persistence was disgusting.

s p: And then you did something which many will see as quite mad: you held your hand in the flame of the lamp and said –

v: 'Let me see her for as long as I can keep my hand in the flame.'

s p: What did he do?

v: He blew out the lamp. 'You shall not see her,' he said.

s p: I suppose you can understand their reaction. Apart from anything else, Kee was still in love with her dead husband. In a way, as with Ursula, you were barging

into an existing relationship.

v: If I were faced by an iceberg from Greenland – I don't know how many metres high, thick and wide – then it would certainly be a critical case if one stood in front of it and wanted to embrace the ice colossus and press it to one's heart and thaw it. But considering that as yet, I hadn't noticed any ice colossus in my sea lane, even with her 'no, never, no' and all – and if I'd measured correctly and she wasn't in fact unembraceable – so I couldn't appreciate the 'senselessness' of my course of action.

sp: You felt people applauded her for saying 'No', more than you, for saying 'Yes'.

v: Tell me, do you think it was tactful of people to pay *her* a compliment because her 'no, never, no,' was unmeltable, unthawable and irrevocable? And yet many people did just that, by making such a thing of her no, never, no.

sp: Friends and family gathered round her, but no one gathered round you.

v: Wouldn't it be more humane of these people if they were willing and able to smile about it? But even so, I wasn't planning on growing despondent about it nor letting go of the courage I'd mustered. God forbid! Let those who wished to be despondent about it be so! I'd had enough of it, and didn't want to be other than as happy as a lark in Spring. I wanted to sing no other song but 'Love on!'

sp: And you'd said all you could.

v: I'd said 'Kee, I feel exactly as though you are the closest

person to me and I the closest person to you, in the fullest sense of the word. I love you as I love myself.' And it was then she said 'no, never, no'.

SP: And how did you feel?

V: At first it was as shattering as damnation. But there is a God and he would that we shall love, and it was precisely that which influenced my work, to which I was more drawn every day, for the very reason that I would succeed. Not that I'd become extraordinary, but something ordinary indeed, by which I mean my work would be sound and reasonable and would have a reason to exist and would be able to serve some purpose.

SP: So you buried yourself in your work. But family tensions were exposed, and you were harsh in tone to Theo soon after, when telling him he should get married.

V: We'll plough him first, I thought – this man who 'deftly dispatches business'. So yes, I wrote as cold as a ploughshare.

SP: Saying what?

V: I said that although he'd come a long way without a 'she and no other'; although he'd deftly dispatched business without a she and no other; although he was a man of will power, energy and character without a she and no other; a man loathful of vacillation, hesitation and doubt – he'd be better still if he found a she and no other!

SP: Theo was a more private person than you; kept his thoughts to himself.

v: Oh yes. I said it's you Theo, more than anyone, who keeps all your great and petty miseries of human life to yourself! I mean, I found such strength of mind very impressive, even though I was far from sympathizing, and was aware that all too often my need for sympathy had in fact tempted me to seek it from those who, instead of bolstering me up, tended rather to weaken my resolve.

sp: Your Ma and Pa?

v: Pa and Ma were really good, but they had little idea of one's actual state of mind and circumstances. They loved us – especially Theo – with all their heart, and at bottom we loved them truly. But alas! In many cases they could not give us practical advice. I said to Theo that no matter how great the love he, Pa and Ma felt for each other, they nevertheless imagined him to be quite different from what he really was. Oh yes, I was being a cold, hard ploughshare!

sp: So what were you advocating – withdrawal from them?

v: I wasn't saying we should hide our heart secrets from Pa and Ma. God forbid! It was also not my opinion that Pa and Ma's advice was wrong or silly. God forbid that too. But there were others who understood more from half a word, than Pa and Ma could from a whole explanation.

sp: And you recommended the book *Jane Eyre* to Theo.

v: That book could tell him many things much more clearly than I could.

sp: But still, much more than you, Theo regarded your parents as his ultimate refuge.

v: Indeed. But even so, there's a refuge that is better, more necessary, more indispensable than our home with Ma and Pa.

sp: And that is?

v: And that is our hearth and home with our own 'she and no other'.

sp: Marriage; union; always your dream – but your parents called your love life 'untimely' and 'indelicate'.

v: Until I begged them very decidedly and definitely, after first having used more temperate reasoning in vain, no longer to apply such expressions to this love of mine, because otherwise I would be forced, proud as a lion, to go against them.

sp: And you asked Theo to talk with them.

v: A word from him probably had more influence on them than anything I could say; and it would be good, both for them and me, if instead of trying to thwart me in my progress, they let me quietly proceed.

sp: There was a different wind in your sails.

v: They thought along the lines of a kind of resignation strategy regarding many things to which I could not resign myself.

sp: Your mother prayed with you in this manner; praying that you would become resigned to things.

v: You must understand that someone who wants to act, cannot entirely approve of his mother praying for

resignation for him!

SP: I can see the frustration.

V: I also found her consoling words slightly misplaced, as I did not accept the yolk of despair.

SP: I'm aware some people's prayers are less than helpful.

V: I would that she hadn't prayed for me; but had given me the opportunity for an intimate conversation with her.

SP: But that would have involved genuine human contact and she could never give you that.

V: Oh, Theo is the one who comforts his mother and who is worthy to be comforted by his mother!

SP: Would you want to be in love again; like you were with Kee?

V: Who knows? But being in love like that wasn't exactly like picking strawberries in Spring.

SP: No.

V: And that no, never, no, wasn't as balmy as a Spring breeze, but as bitter, bitter, bitter as a biting winter frost. 'This is no flutter,' as Shakespeare would say.

SP: But in matters of the heart, you were always stubborn and never took advice.

V: Trying the exact opposite of some advice often proved both

practical and satisfying. That's why it was useful in so many cases to ask for advice.

SP: So you could do the exact opposite?

V: There is advice that's usable and doesn't need to be turned inside out and upside down. This latter kind is very rare and desirable, because it has special qualities. The former can be had ten for a penny. The latter is dear; the former, however, costs nothing and is sometimes delivered unasked for by the barrelful!

SP: You certainly trampled on advice in your relationship with Sien Hoornik, who followed Kee in your affections. And a rather different sort of woman.

V: I don't think what some call God and others the Supreme Being and others Nature, is unreasonable and merciless; and heavens, I didn't look so very far.

SP: You found a woman without looking.

V: Yes, I found a woman, by no means young, by no means pretty, with nothing special about her. She had one foot in the grave when I met her; and her mind and nervous system were also upset and unbalanced.

SP: You're wasting no time with flattery.

V: She was fairly big and strongly built, and she didn't exactly have ladies' hands like Kee, but those of a woman who worked hard. She was alone and forsaken like a worthless rag. But she was not course and not common; and had something very feminine about her – what the French call 'a working woman'.

SP: A prostitute?

V: Yes, she was a whore, already pock-marked, withered and prematurely old. Yet in my eyes, she was beautiful and I found in her exactly what I wanted.

SP: She represented something good?

V: Her life had been rough, and sorrow and tribulation had put their marks on her; I felt I could do something with her.

SP: Was it sympathy?

V: It was not the first time I couldn't resist the feeling of affection; particularly the love and affection for those women whom the clergymen damned so and superciliously despised and condemned from the pulpit.

SP: You'd heard a few of those sermons.

V: Well, I didn't damn them or despise them! In fact, when ever I walked down the street – often all alone and at a loose end, half-sick and destitute, with no money in my pocket – I looked at them, and envied the person who could go off with such women.

SP: You identified with these women?

V: Yes. I felt as if these poor girls were my sisters, as far as our circumstances and experience of life was concerned. Even as a boy, I sometimes looked up with endless sympathy into a half-withered female face on which it was written, as it were: life and reality have given me a drubbing.

SP: And so you set up home with Sien, who was pregnant when you met her.

V: She had a difficult birth, poor creature of a mother, and aren't there moments in life when remaining inactive and saying 'What's it to do with me?' is criminal? At any rate, I said to the woman, when you're better, move in with me. This woman had another child as well, a sickly neglected lamb – it was an undertaking that was considerably beyond my strength but what can you do?

SP: And what could you do?

V: She moved in and the baby turned out to be quite delightful. A child in the cradle, if you watch at leisure, has the infinite in their eyes. Young corn has something inexpressibly pure and tender about it, which awakens the same emotion as the expression of a sleeping baby.

SP: You remember the birth with affection.

V: That eternal poetry of Christmas night with the infant in the stable, as the old Dutch masters conceived it. He was like the sun, a light in the darkness; a brightness in the middle of a dark night. I fetched his cradle from a junk shop on my shoulders, and that child – for me, he was a light in the house the whole dark winter. So you see that while I tried to penetrate deeper into art, I also tried to do that in life itself – the two go together.

SP: But Theo didn't approve of this relationship.

V: No.

SP: You reckoned it was a second-hand disapproval, borrowed distaste, passed on by your parents. But you gave him an ultimatum nonetheless.

V: I said if he stayed of the same mind, I would no longer be able to esteem him precisely as I had in the past; that I would no longer have the respect as before.

SP: And your father?

V: You will understand that he wasn't best pleased when he first heard about it.

SP: You surprise me.

V: But when he heard of the details, he looked at it differently from at first. He even paid me a visit while I was living with her.

SP: A noble gesture, which must have cost him something. And other painters? Do they have a view about such things?

V: Among the painters, there were considerations of decency I didn't exactly understand.

SP: Oh.

V: Contact with painters has always been a severe disappointment to me. They appear warm-hearted but all too often try to trip you up. That's the fatal thing. We should help and trust each other, for there are hostilities enough in society. Envy drives many to malign each other, systematically.

SP: Painters at war.

v: A battle with paintings and drawings is good in a sense, but we shouldn't become personal enemies of each other or use other methods of war. There's much that's good in the present – or would be more than is actually the case – if there were rather more joining together.

sp: Though in the end, you and Sien did not remain joined. You hoped you could do something for her, but you couldn't; it was all too much, and you left her in the Hague. I gather she was too lazy for you.

v: Unless she became more active of her own accord, three helpers in my place wouldn't have been able to do anything.

sp: No.

v: But it's the children to whom one's heart goes out. I couldn't do everything for them – but if only the woman had been willing! Work was more directly my duty than even the woman –

sp: – painting work –

v: – and the former couldn't suffer for the sake of the latter.

sp: And you left your new address with the carpenter next door, but she didn't write.

v: I couldn't understand why, so I wrote to the carpenter asking whether the woman hadn't been to him for the address. Well, the blackguard wrote back to me: 'Oh yes, sir, but I thought you certainly wouldn't want her to know your address, so I just pretended I didn't know it.' Bastards!

SP: Let's be honest, you have not been lucky in love, Vincent; and the rejections – both yours and others – seem to live on inside you.

V: It's just as impossible for someone who loves to take back that feeling, as it is to take one's own life; and really, I don't think I'm a man with such inclinations.

SP: And so you burn inside with longing.

V: Well, there may be a great fire in my soul, yet no one ever comes to warm themselves at it. The passers-by see only a wisp of smoke from the chimney and continue on their way.

SP: Do you feel lonely?

V: I prefer to make fun of myself than to feel lonely.

# *Who is my mother?*

*What I've discovered is this: before we talk about Vincent van Gogh, we have to talk about Vincent van Gogh, and this isn't a misprint.*

*Vincent van Gogh was born and died on 30 March 1852. The second Vincent van Gogh was born exactly a year later, on 30 March 1853. Explanation? In order to remember the dead Vincent, his parents decided to name their next boy after him, thus giving the dead child continued life. And so Vincent van Gogh followed Vincent van Gogh.*

*Some people suggest his parents never forgave the living Vincent for not being the dead one – unreachable now in the grave, which the young Van Gogh was made to visit regularly. Buried there was both the boy and the man Vincent could never be. Is this what Vincent felt, I wonder? They even shared a birthday!*

*From what I understand, the young Vincent struggled to find an identity as a child. Did he believe himself to be a poor replica of someone else, someone better, someone untouchable in their perfection; and someone who in death could never mess things up, in the way he always seemed to?*

*I notice he only uses 'Vincent' when he signs his paintings; not a single drawing or painting bears the family name. I ask him about this and he says it was because foreigners couldn't pronounce 'Van Gogh'. This may be true, but is probably not the whole truth. It's hard not to see it as an act of separation from the Van Gogh family. All the more so, as I hear that once – after calling his father obstinate, icy cold, unintelligent and narrow-minded – he*

declared 'I am not a Van Gogh!'

*Vincent doubts his own ability, and as someone cruelly said, 'his parents encouraged him in this doubt'. It was his sister Anna, however, who thought he should be a baker. Concerning his siblings, he has three sisters, Elisabeth, Anna and Wil; and two brothers, Theo and Cor. He is only in contact with Theo and Wil, to whom he writes lovely letters.*

*Vincent has no discernible affection for his mother, apart from the time when she was ill; he could always relate to suffering. With his father, it was a stormy relationship; but a relationship nonetheless, including occasional warmth alongside the fury.*

v: I wish they would only take me as I am.

sp: That's how you feel about your parents?

v: I wish they could take me as I am.

sp: You feel they don't want you.

v: They feel the same dread of taking me into the house as they would about taking in a big rough dog. He would run into the room with wet paws – and he is so rough! He will be in everybody's way. And he barks too loud. In short, he is a foul beast!

sp: You felt uncouth and intolerable to your parents.

v: My youth was gloomy, cold and sterile. The germinating seed must not be exposed to a frosty wind – that was the case with me in the beginning.

SP: Your father's death appeared to mean little to you; you do not speak of it. But there were good times with that man.

V: Oh yes. I remember one evening, when we rode back from Zundert over the heath, Pa and I walked a way, the sunset red behind the pines, and the evening sky reflected in the marshes, the heath and the yellow and white and grey sand were so constant with tone and atmosphere. You see, there are moments in life when everything within us too is peace and atmosphere, and all of life seems to be like a path across the heath – though it isn't always so.

SP: In the early days, they set up a studio for you in the laundry room of the parsonage.

V: They did.

SP: And your father helped financially.

V: Pa really didn't profit from me, and it weighs heavily on my heart. More than once he bought me a coat and trousers, for example, which I'd actually rather not have had, even though I really needed them. But Pa shouldn't have suffered by it; and the more so, if the coat and trousers didn't really fit.

SP: They didn't fit? That was unfortunate.

V: And I found it absolutely terrible not to be free at all, because even though Pa didn't account for every penny, still he knew how much I spent, and what I spent it on.

SP: It's difficult when you both need support and resent it. Did you worry about your future?

v: I would have seen less of a problem in the future if I had been less awkward in dealing with people.

sp: You foresaw problems with people, and with Kee Vos that was certainly true. Your parents said that you'd break ties over it.

v: It was said, yes, 'that I'd break ties'.

sp: And would you have?

v: I'd said many times with seriousness, with patience, with feeling, that this wasn't the case at all. But when, so over-hastily and stupidly in my opinion, the awful expression 'breaking ties' went on and on, I did the following. For a couple of days, I spoke not a word and took not the slightest notice of either Pa or Ma.

sp: You lived in the same house, but imposed silence.

v: Reluctantly, but still I wanted to make them feel what it would be like if ties were really broken!

sp: How did they react?

v: Naturally my behaviour surprised them, and when they told me so, I answered, 'You see, this is how it would be if there was no bond of affection between us, but fortunately it does exist and won't be so easily broken for the present. But see for yourself, how wretched words like 'breaking ties' really are; and don't say them anymore!'

sp: Strong words – but I can't see your father backing down.

v: Pa became very angry, sent me out of the room and cursed me – at least that's what it sounded like.

sp: A father cursing his son?

v: It caused me much sorrow and grief, but I refused to accept that a father was right who curses his son, and wants to send him to a mad house –

sp: That was his suggestion?

v: – which I naturally opposed with all my might.

sp: That must have been hard for you, up against your father. Some people would call that 'The Last Battle.'

v: When Pa got angry, he was used to having people, including me, admit that he was right. Now though, I'd firmly resolved to let his anger burst forth, for God's sake. Pa also said something about me having to move somewhere else, but because it was said in anger, I didn't attach much importance to it. Here I had my models and my studio – life would have been more expensive elsewhere.

sp: So in the heat of the fight, you weren't getting emotional; you were getting financial!

v: If Pa and Ma said to me calmly, leave – well, then of course I would leave, for there are things one cannot take lying down. I said to Ma and Pa their view seemed bigoted and not broad-minded and generous enough. Also, that it seemed to me that the word 'God' would have only a hollow ring to it, if one had to conceal love and weren't allowed to follow the promptings of one's heart.

SP: This was over Kee Vos?

V: In any event, Pa, in his anger, uttered neither more nor less than a curse. But I had heard something similar the year before, and thank God, far from being damned in reality, new life and new energy had developed in me.

SP: The curse had proved powerless.

V: So yes, I had every confidence that it would be like that this time; only more and stronger than last year. In fact I said to Theo, 'I, Vincent, and you Theo, were not born for resignation but for vigorous faith!'

SP: A strange expression from you.

V: Pa and Ma got annoyed again and again at words and expressions of mine, or their tone, and were often confused as to my actual meaning and imagined I wished to insult or distress them.

SP: I understand things got so bad that in the end, you father did ask you to leave.

V: He would say, 'You'll be the death of me,' while calmly reading the newspaper and smoking his pipe. Or else he'd get incredibly angry; used to people being afraid. He was very easily hurt and irritable and full of obstinacies in domestic life and expected to get his own way.

SP: It feels like constant war.

V: Pa and Ma couldn't stand 'bad blood'. But as they created a desert around themselves, they were making their old age

miserable when it could have been good and satisfying.

sp: Did you think that was your fault?

v: Before things got bad, I felt a great deal of remorse and sorrow, and tormented myself. But when events unfolded as I've described, well, so be it, I thought.

sp: You were no longer sorry.

v: I was no longer sorry, no; in fact I couldn't help but feel relieved. And as I reflect, I still don't see how exactly it would have been possible to act otherwise. When someone tells me in no uncertain terms, 'Leave my house, the sooner the better, within the half-hour rather than the hour' – well, old chap, then I'm out in less than a quarter of an hour, and won't come back again either.

sp: And you didn't; you never went back home.

v: It really was too bad, and the path I had to take was clear enough.

sp: And nothing was resolved between you and your parents.

v: Nothing. The disharmony between father, mother and me became a chronic evil because there was misunderstanding and estrangement between us for too long. I felt like a half-strange, half-tiresome person.

sp: Not a comfortable feeling to live with.

v: The history of the Eighty Years' War is really wonderful.

SP: Because?

V: Because anyone would do well to make such a good fight for his life! Truly, life is a fight, and one must defend oneself and resist and make plans and calculations with a cheerful and alert mind, in order to make it through and get ahead.

SP: And does it get easier as one gets older?

V: It gets no easier the further one gets in life, and it has been rightly said:

'Does the road go uphill all the way?'
'To the very end.'
'And will the journey take all day long?'
'From morn 'til night, my friend.'

SP: It sounds like a particular crown of thorns has been pushed hard down on your head.

V: It's been a 'crown-of-thorns' life, yes. But fighting difficulties in which one finds oneself, an inner strength develops from within the heart, which improves in life's fight.

# *Paris*

—

*According to Theo, Vincent's stay in Paris was a frustrating time. He met many fine artists; but also felt thwarted. 'In Paris,' said Theo, 'Vincent saw many things he wished to paint, but was always denied the opportunity. The models wouldn't pose for him; he was forbidden to work in the streets and because of his violent temper, there were continual incidents. In time, he became completely unapproachable and in the end, became heartily sick of Paris.'*

*So this was Theo's verdict. But would Vincent's memories be the same?*

SP: What was your experience of Paris?

V: The first time I saw it I felt, above all, the miseries that one cannot wave away, any more than the smell of the sickness in the hospital, however clean it may be kept.

SP: Not a pleasant image. Is the smell that bad?

V: I think the country air has an enormous effect. In this very street in Auvers, there are youngsters who were born in Paris and were really sickly – who, however, are doing well now.

SP: But you also saw another side to the city?

V: I later gained an understanding of it as a hotbed of ideas, and saw how the people tried to get everything out of life that could possibly be in it.

SP: So how does it compare to other cities, for you were well-travelled by this time?

V: Other cities shrink by comparison, as it is as big as the sea.

SP: And you didn't miss the countryside?

V: One always leaves a whole piece of life behind there. And this is certain: nothing is fresh in Paris!

SP: The ideas were fresher than the vegetables?

V: That's why, when one comes from there, one finds a mass of excellent things elsewhere. But Paris is beautiful in the autumn. And Notre Dame is absolutely beautiful in the evening among the chestnut trees.

SP: I agree.

V: There's something in Paris that's even more beautiful, though, than the autumn and the churches.

SP: And what's that?

V: The poor people there.

SP: Ah.

V: I sometimes think of many a person there, London and Paris. I've loved so much about those two cities. I think back on them with a feeling of nostalgia.

SP: But in Paris your attitude to marriage changed.

v: I felt myself losing the desire for marriage and children, yes, and at times was quite melancholy to be like that at 35, when I ought to have felt quite differently.

sp: And did that affect your painting? It seems you began to be more adventurous with colour at that time.

v: The year before, I'd painted almost nothing but flowers, so as to get used to colours other than grey – colours like pink, soft or bright green, light blue, violet, yellow, orange, glorious red.

sp: But *why* the change then?

v: Regarding myself as a deteriorating little old man, I suppose I attempted pictures in which there was some youth and freshness, even though my own youth was one of the things I'd lost.

sp: So there you were, a fit man of 35, suddenly feeling old and a man beyond love – what was happening to you?

v: I sometimes blamed this damn painting. As Richepin said, 'The love of art makes us lose real love.'

sp: Which must have made you all the more determined to succeed as an artist.

v: To succeed, you have to have ambition and ambition seemed absurd to me. I didn't know what would come of it.

sp: Paris, though, was seething with artistic ambition; and you met a lot of painters there. Pissarro, Signac, Seurat; Gauguin, Toulouse-Lautrec and Cézanne, some of whom

actually sold their pictures. You must have learned about brush work from them? A new system, perhaps?

v: My brush work has no system at all! I hit the canvas with irregular touches of the brush, which I leave as they are. Patches of thickly laid-on colour, spots of canvas left uncovered, here or there portions that are left absolutely unfinished, repetitious, savageries.

sp: I see.

v: In short, I'm inclined to think that the result is so disquieting and irritating as to be a godsend to those people who have preconceived ideas about technique!

sp: But you gained respect for the Impressionists, which not everyone had.

v: People had heard of the Impressionists, and had great expectations of them, and when they saw them for the first time, they were bitterly disappointed.

sp: Why was that?

v: They found them careless, ugly, badly painted, badly drawn, bad in colours – everything that's miserable.

sp: You're not selling them to me.

v: That was my impression too when I first came to Paris. Then I saw them, and though I wasn't quite one of the club, I admired certain Impressionist pictures.

sp: Such as?

v: Such as Degas' nude figure or Claude Monet's landscape.

sp: You found kindred spirits.

v: A painter is someone who paints, and so those twenty or so painters who you call Impressionists – although a few of them have become fairly rich and quite big men in the world – the majority of them were poor souls who lived in coffee houses, lodged in cheap inns and lived from one day to the next.

sp: And of course you loved the revolutionary ideas of the French writers as much as the Dutch Calvinists hated them! Perhaps in Paris you felt part of a new band of revolutionaries; revolutionaries with the brush!

v: In one day, they paint everything they set their eyes on, and are better than many a 'great man' in the world. So yes, I felt bound to the French painters whom people call Impressionists. I knew many of them personally, and liked them. And in my own work, I've had the same ideas about colouring.

sp: And you worked hard in Paris, producing 200 oils. Yet despite everything, it doesn't sound like a happy place for you.

v: I decided to leave Paris and retreat somewhere in the South – so as not to see so many painters who repelled me as men.

sp: Are these the same ones you just said you liked?

v: In Paris, one is always as sad as a cab horse.

sp: Your depression returned?

v: When I left there, I was seriously ill, sick in both heart and

body, and nearly an alcoholic. In Paris, I could never accustom myself to climbing stairs, and I always had fits of dizziness in a horrible nightmare which has left me since, but which came back regularly then.

SP: You suffered from nightmares?

V: Abominable nightmares. Arles was the first time I slept without a bad nightmare.

SP: That sounds rather tragic.

V: The history of great men is tragic! For long periods of their lives, they endure depression because of the opposition and difficulties of battling through life. Good night.

SP: Good night, Vincent.

## Colour my world

*When Vincent moved to Arles in the South of France, he discovered 'a kingdom of light'. He'd left potato-coloured Holland for the solar-bright illuminations of another land, and was born again as an artist. He painted everything – cafés, children, stars, people, chairs, night, trees, sunflowers; even his bedroom. The cold northern skies of childhood were with him no more and it appeared to send him into an explosion of creativity.*

*The painter Gauguin joined him there. Gauguin, five years Vincent's senior, liked Theo, and believed that in Theo, he had a fan. 'You well know that in art I am fundamentally right,' he wrote to him. 'Mark this well – at the moment among artists, a wind is blowing which is decidedly favourable to me.' Those are not words that Vincent could have spoken.*

*Neither am I sure that Vincent alone, could have persuaded Gauguin to join him. But with an art dealer for a brother, there were other inducements.*

SP: So you left Paris for the south. And the colours you ordered on arrival in Arles must have been rather different.

V: Hardly one of them was to be found on the Dutch palette. There was there that sulphur-yellow, everywhere the sun lit. And the green and the blue! I must say several landscapes of Cézanne's which I know, render this very well and I am sorry not to have seen more of them.

SP: But why Arles in particular? Gauguin called it 'the dirtiest town in the whole south.'

v: I was looking for a different light, and I felt that nature
there had everything I needed to make good things

sp: Like the Japanese light? You loved Japanese paintings.

v: The colours of the prism were veiled in the mists of the
north. And I liked the flat landscape, where there was nothing
but infinity; eternity. So it would be my fault if I didn't
succeed. I had the pure air and the heat, which made things
more possible for me. I had work and nature in Arles.

sp: And those were both important.

v: If I don't have those I become melancholy; even if
foreigners were exploited there.

sp: In Arles?

v: It was considered a duty by the locals to get all they could
out of them.

sp: So they weren't your favourite people.

v: They were often more handsome. Only it seemed to me
they were getting a bit slack, slipping a little too much into
the downward slope of carelessness and indifference, whereas
if they'd been more energetic, the land would probably yield
more.

sp: Perhaps it was the heat that slowed them down. Did that
affect you?

v: I felt fine working in the hottest part of the day. It's a clear
dry heat. And the colour there was actually very fine. When

the vegetation is fresh, it's a rich green the like of which we seldom saw in the north.

sp: But presumably it withered in the heat, and was then less beautiful.

v: No, when it got scorched it didn't become ugly, not at all; for then the landscape took on tones of gold of every shade – green-gold, yellow-gold, red-gold, ditto bronze and copper; in short, from lemon-yellow to the dull yellow colours of say, a pile of threshed grain; that with the blue – from the deepest royal blue in the water to the forget-me-nots. Cobalt above all – bright clear blue, green-blue, violet blue.

sp: Intoxicating even in words.

v: Naturally, this induces orange – a face tanned by the sun looks orange; and because of all the yellow, the violet really spoke – a wicker fence or grey thatched roof or a ploughed field look much more violet than at home.

sp: The south sounds like a shock to the eyes!

v: Not necessarily, because by intensifying all the colours, one again achieves calm and harmony.

sp: But you say bright colours are what people want now.

v: People prefer sunny and colourful effects, like the colourful Japanese pictures one sees everywhere, landscapes and figures. Yes, today's palette is definitely colourful – sky blue, pink, orange, vermillion, brilliant yellow, bright green, bright wine red and violet.

sp: In the north, you painted fairly sombre settings, with heroes like Rembrandt and Millet.

v: Rembrandt and Millet were more harmonists than colourists. But painting grey as a system was becoming intolerable and I certainly wished to see the other side of the coin.

sp: And even as you prepared to leave the Dutch gloom, you were looking more and more at colourists like Delacroix and Rubens.

v: Delacroix expressed an enormous variety of moods in symphonies of colour. And there in the South, the stretches of water made patches of a beautiful emerald and a rich blue; pale orange sunsets made the fields look blue – and glorious yellow suns!

sp: You were a man with a mission.

v: Man is not placed on this earth merely to be happy; nor is he placed here merely to be honest. He is here to accomplish great things through society – to outgrow the vulgarity in which the existence of almost all individuals drags on. And the uglier, older, meaner, iller and poorer I got, the more I wished to take my revenge by doing brilliant colour, well arranged, resplendent!

sp: And that you have done. The art critic Aurier has recently written that you are 'the only painter to perceive the chromatism of things with such intensity, with such metallic, gem-like quality.'

v: I learned that from Monticelli, a man who gives us not

– neither pretends to give us – local colour or even local truth. But rather, gives us something passionate and eternal – the rich colour and rich sun of the south, in a true colourist parallel to Delacroix.

SP: With you, colour is an adventure in itself.

V: Find things beautiful as much as you can; most people find too little beautiful. Poetry surrounds us everywhere, but putting it on paper, alas, is not so easy as looking at it!

SP: And do you have favourite colours?

V: Carmine and cobalt – I'm really carried away by these two colours. Cobalt is a divine colour, and there's nothing so fine as that for putting space around things. Carmine is the red of wine, and it's warm, spirited as wine. So too is emerald green. It's false economy to do without these colours. Cadmium likewise.

SP: So there are colours that help each other?

V: There are colours that make each other shine, yes; that make a couple, complete each other like man and wife. There is no blue without yellow and without orange.

SP: Now I'm thinking of your *Starry Night over the Rhone* which is here somewhere. But you probably use the same idea elsewhere.

V: Take cornflowers with white chrysanthemums and a few marigolds. There also you have a motif in blue and orange.

SP: And other combinations?

v: Poppies or red geraniums in bold green leaves; a motif in red and green. Or heliotrope and yellow roses; a motif in lilac and yellow.

sp: And so it was you left the grey behind.

v: The South of France was the land of blue tones and gay colours, where there's even more colour and even more sun.

sp: Colours and sun you hadn't seen before.

v: The Dutch are as blind as moles and criminally stupid because they don't make more effort to go to the Indies or somewhere else where the sun shines. It's not good to know one thing; it stultifies. One shouldn't rest until one also knows the opposite.

sp: Though let's be honest, Vincent – you never rest, do you? Not for a moment. If you're not painting, then you're out; and if you're not out, you're reading – newspapers, magazines, novels. Which reminds me – and it's by way of nothing at all – but on your table yesterday, I was surprised to see two Christmas ghost stories by Charles Dickens. *A Christmas Carol* and *The Haunted Man*. Are these favourites of yours?

v: I have re-read those two children's tales nearly every year since I was a boy, and they are new to me again every time.

sp: I wonder why? I mean, I've read them myself; two stories in which ghosts come along and give life back to melancholic men.

v: Well, it's better to have a gay life of it, than commit suicide!

sp: But do you think it possible that you too are looking for a ghost to save you; looking for the ghost of your dead brother? You've said you're attracted to cemeteries. I mean, your favourite walk in Amsterdam apparently, is an unusual one – the East Cemetery, where you picked snowdrops?

v: Preferably from under the snow.

sp: And you also have strong memories of the cemetery in Zundert, where the first Vincent was buried. Why do these memories disturb you?

v: It's because I still have the most primitive recollections of those first days; more than anyone. There is no one left who remembers all this but mother and me.

sp: Remembers what exactly?

v: I say no more about it, since I had better not try to recover all that passed through my head then.

sp: Hard things for a child?

v: I will quote only from the poem by de Musset: 'Wherever I have touched the earth – an unfortunate man in black would sit down close to us; one who looked upon us as a brother.'

# *Van Gogh, painter*

*In his discipline and commitment, Vincent is like a monk to his art; though not a monk in all ways. He tells me that in Arles, he needed to go to a brothel perhaps once every couple of weeks.*

SP: You worked hard in Arles.

V: There was much to do there, all sorts of studies, not the way it was in Paris, where you couldn't sit down wherever you wanted. So yes, working all the time. In the evening we were dead beat and would go off to the café, and after that, early to bed. Such was our life!

SP: The new light captivated you.

V: We painters must get our orgasms from the eye. Anything complete and perfect renders infinity tangible, and the enjoyment of any beautiful thing is, like coitus, a moment of infinity.

SP: You gave some interesting advice to Bernard along those lines.

V: Don't fuck too much, I said. Your painting will be all the more spermatic. Delacroix did not fuck too much, and only had easy love affairs, so as not to curtail the time devoted to his work.

SP: And are all artists like this?

V: No. Rubens! Ah, that one. He was a handsome man and a

good fucker; Courbet too. Their health permitted them to eat, drink and fuck.

sp: But for you as a painter, not blessed with such health, a visit to the brothels once every two weeks was enough?

v: Look, I know full well that whores, strictly speaking, are bad. But I sense something human in them which prevents me from feeling the slightest scruple about associating with them. If our society was pure and well-regulated, yes, then they would be seducers. But now, in my opinion, one may consider them more as sisters of charity.

sp: That's one way of looking at them.

v: They have a certain passion, a certain warmth which is so truly human that the virtuous people might take them as an example.

sp: I can guess who you have in mind. But let's move on, and consider you as a painter –

v: Myself as a painter? I'll never signify anything important; I sense it absolutely.

sp: Why do you say that?

v: Supposing everything were changed – character, upbringing, circumstances – then this or that could have existed. I sometimes regret not having simply kept the Dutch palette of grey tones.

sp: I don't share that regret. And although you run yourself down, at least you've tried to bring painters together. After

your Parisian experiences – where you found them an unpleasant and jealous group – you encouraged an irenic, less critical spirit amongst them.

v: I said to Émile Bernard: if you've already discovered that Signac and the others who are doing pointillism often make very beautiful things with it – instead of criticizing them, one should respect them and speak of them sympathetically; otherwise one becomes a narrow sectarian oneself, like those who think nothing of others, and believe themselves to be the only righteous ones.

sp: And you don't like a righteous attitude in painting or religion.

v: Put aside petty jealousies – the 'each man for himself' – for the common interest.

sp: So it was a relief to get to Arles after Paris?

v: Yes, it seemed to me my blood was more or less ready to start circulating again, which wasn't the case in Paris. I really couldn't stand it any more. And in Arles, I began to get quite tanned.

sp: A new experience for Vincent.

v: The people there were tanned by the sun, yellow and orange in colour, and sometimes red and ochre.

sp: You liked your new exile in the south. But Arles was a cultural backwater – and I'm wondering if being so far from the centre brought problems?

v: Yes, I had to buy my colours and canvases from either a grocer or a bookseller, who didn't have everything I wished for!

sp: I can imagine. And there weren't bullfights in Paris either; but in Arles, every Sunday.

v: I remember one Sunday a bull jumped over the barrier, and then jumped up against the terraces where the spectators were sitting.

sp: I'd be making for the back row.

v: But the arenas were so high it could do no harm. Though in a village nearby, a bull jumped out of the enclosure, made its way through the spectators, injured several of them, and ran through the village.

sp: What happened then?

v: At the end of the village, which was built on a rock, there was an enormously high steep cliff. In its rage, the bull kept running and plunged to its death below.

sp: But you stayed alive, and lived in the Yellow House.

v: That's right. I lived in a little yellow house with green door and shutters, whitewashed inside – on the white wall, very brightly coloured Japanese drawings, red tiles on the floor.

sp: You remember colour.

v: I remember the house full of sun, and a bright blue sky above it.

SP: And your desire was that this house would become home for a community of artists.

V: I still hoped not to work for myself alone, yes. I believed in the absolute necessity of a new art of colour, of drawing and of the artistic life. And if we worked in that faith, it seemed to me there was a chance that our hopes wouldn't be in vain.

SP: Almost a monastic community; and you knew just how the Yellow House should look.

V: I really did want to make it an artist's house, but not affected – on the contrary, nothing affected, but everything, from chairs to tables, full of character.

SP: And Gauguin came to stay for a while, a man you looked up to.

V: I knew well that he had made sea voyages, but I did not know he was a regular mariner.

SP: Nor did anyone else.

V: He had passed through all the difficulties, and had been a real able seaman and true sailor. This gave me an awful respect for him and still more, absolute confidence in his personality.

SP: I'm told Gauguin doesn't always tell the truth. But then, who does? And anyway, I want to speak more about painting. And in particular, about what determines the success of a painting?

V: The success or failure of a drawing has a lot to do with one's mood or condition, I believe. And that's why I do what I can

to stay clear-headed and cheerful.

s p: That helps your work?

v: Sometimes some malaise or other takes hold of me, and then it doesn't work at all.

s p: But you like emotion in painting and literature.

v: Sometimes there's something indescribable in those effects. It's as if the whole picture is speaking. I've just finished a book by Victor Hugo, for instance, and I cannot understand that not everyone sees or feels it! After all, nature or God does it for everyone who has eyes and ears and a heart to perceive.

s p: When you showed Cézanne one of your pictures, he saw the emotion and said: 'Honestly – your painting is that of a mad man!'

v: The message is to keep on working. Mauve, my early teacher, was able to benefit from every mood.

s p: And do you have teachers now?

v: Not really. Because I've worked entirely alone for years, I imagine that although I can learn from others, and even adopt technical things – all the same, I'll always see through my own eyes and tackle things originally.

s p: And of course you are a people-watcher. Everyone you meet is a picture!

v: I remember in Antwerp my thoughts were full of Rembrandt and Hals, not because I saw paintings by them,

but because I saw so many types of people who reminded me of that age. I went often to the dance halls to see women's heads and sailors' or soldiers' heads. I paid 20-30 centimes to go in and drink a glass of beer. I amused myself for whole evenings watching the folks in high spirits.

SP: So how do you paint?

V: I dream of painting.

SP: You dream of painting?

V: And then I paint my dream. I experience a period of frightening clarity in those moments when nature is beautiful. I am no longer sure of myself, and the paintings appear as in a dream.

SP: And does nature assist you in your dream – or does she set herself against you?

V: Nature always begins by resisting the painter, but he who truly takes it seriously doesn't let himself be deterred by that resistance. On the contrary, it's one more stimulus to go on fighting; and at bottom, nature and an honest painter see eye to eye.

SP: She's an elusive prey, though?

V: Nature is most certainly intangible – yet one must seize it, and with a firm hand. And then, after struggling and spending some time with nature, it becomes a little more yielding and submissive. It resembles what Shakespeare calls 'The Taming of the Shrew'!

sp: You sound like a miner, deep underground, hacking at the rock in search of gold. .

v: In many things, but particularly in drawing, I think that delving deeply into something is better than letting it go.

sp: And your brush makes nature live. Everything you paint has life!

v: If one draws a pollard willow as though it were a living being, which it actually is, then the surroundings follow more or less naturally; if only one has focused all one's attention on that one tree, and haven't rested until there is some life in it.

sp: Like God at the beginning of time.

v: If we don't draw figures – or else trees as though they are figures – then we're like people with no spine; or at least someone who's too weak. Millet and Corot, who Theo and I like so much – they could paint a figure, couldn't they? I mean, those masters baulked at nothing!

sp: And you don't mind people watching you paint. I know some artists get irritated by onlookers. Indeed, I've irritated a few myself!

v: It gives me great pleasure to work outside as someone looks on.

sp: And perhaps if people did, they'd better understand the artist.

v: Twenty or so fellows who can do whatever landscape you please, at whatever hour of the day, with whatever effect you

please, on the spot without hesitation – yet nobody looks on, they always work alone. But yes, anyone who did, would certainly keep his mouth shut afterward about the clumsiness of the Impressionists and their bad painting!

SP: I can see that.

V: Nowadays, we seldom have acquaintances who are interested enough to come along. But when they do, they're sometimes won over for good.

SP: Particularly as you battle with the elements.

V: Painting is hard work because of the wind, but I fasten my easel to pegs driven into the ground and work in spite of it; it is too lovely.

SP: The rattling easel fastened to pegs, driven in to the hard earth, while the wind-swept painter paints on! That's a great image.

V: Now contrast that with the fellows who need a studio for months and months to make something – and only too often something rather dull, after all that.

SP: So yes, perhaps painting will become a spectator event in the future; a form of entertainment in itself.

V: One is in the wheat, say. Well then, in the space of a few hours one has to be able to paint the wheat field and the sky above it, and the prospect in the distance.

SP: Beats watching bull fights.

v: I imagine that in generations to come this working decisively without hesitation, measuring correctly in an instant, skilful mixing of colouring, drawing at lightening speed – a generation will come that will do this not as we do now, alone, unloved; but with a public that will like it both for portraits of people and for portraits of landscapes and interiors.

sp: Listening to you, I sense that wherever you are, you're incredibly aware of nature. But does nature ever stop speaking to you, and become dry?

v: Often – and then it helps to turn to something different. If I'm dead to landscape or effects of light, I tackle figures or vice versa.

sp: Do you prefer landscapes to portraits?

v: Today I'm a landscape painter, whereas I'm actually more suited to portraits. Altogether, it is the only thing in painting that moves me deeply; and which makes me feel the infinite more than anything else.

sp: I know you discussed portraiture with Gauguin.

v: Until our nerves were strained to the point of stifling all human warmth!

sp: Ah.

v: But no, it wouldn't surprise me if I were to change my style again sometime.

sp: And talking of people changing styles – and forgive the

gossip – but I hear the painter Chaplin, who used to paint pig herds on bleak moors, now paints glamorous women in boudoirs, dressed or otherwise!

v: One has to do what lies to hand –

sp: – and pays? –

v: – but hold fast to one's technique.

sp: Right. Though Gauguin was keen for you to change your technique; paint not from what you saw, but from your imagination.

v: Yes, and I once or twice allowed myself to be led astray into abstraction. At the time, I considered it an attractive method. But that was delusion, and one soon comes up against a brick wall.

sp: You preferred real life?

v: The hand-to-hand struggle with nature, yes.

sp: Like the night sky, for instance, and I'm very fond of your *Starry Night* – yet you told me this morning you weren't happy with it.

v: Once again, I allowed myself to be led astray into reaching for the stars that are too big – another failure – and I have had my fill of that.

sp: But in the hand-to-hand struggle with nature, you don't seek the photographic image. Rather, you aim to place your own distortions into the image.

v: That's right. Zola creates, but does not hold up an image to things. He creates wonderfully, but creates, poeticizes. I should be desperate if my figures were correct.

sp: The Dutch artists tended to be correct.

v: Those Dutchmen had hardly any imagination or fantasy; but their good taste and scientific knowledge of composition were enormous.

sp: You follow Millet.

v: Millet is a real artist for the very reason that he does not paint things as they are, traced in a dry analytical way, but as he *feels* them. Real painters do not paint things as they are. They paint them as they themselves feel them to be.

sp: Are photographic images too perfect, perhaps?

v: Remember what they said about Rembrandt's *Anatomy Lesson* – that painting's only fault is not to have any faults.

sp: And so there's much of Vincent in every portrait you paint?

v: Do not quench your inspiration and your imagination; do not become the slave of your model!

sp: And tell me – is it necessary to like your model?

v: An artist needn't be a clergyman or churchwarden, but he certainly must have a warm heart for his fellow men.

sp: And looking briefly now at one or two paintings, there's

certainly a lot of feeling in this one, called *The Night Café*. This is Arles, I presume?

v: I have tried to express the idea that the café is a place where one can ruin oneself, go mad or commit a crime.

sp: It does feel lurid and somehow dangerous.

v: The picture is one of the ugliest I've done. I've tried to express the terrible passions of humanity by means of red and green. It is like a devil's furnace.

sp: And then over here, something completely different, *The Potato Eaters*, painted in the north. It remains a favourite of yours, though I have to say it divides people. Some find the grim hovel and the five figures round the table quite disturbing. So what were you trying to do here?

v: I tried to emphasize that these people, eating their potatoes in the lamplight, have dug the earth with the very hands they put in the dish, and so it speaks of manual labour, how they have honestly earned their food.

sp: Perhaps it offends Dutch cleanliness.

v: But yes, this painting of the peasants eating potatoes is after all the best thing I did.

sp: And is that enough? Does the act of creation give you enough happiness to sustain you?

v: I shall count myself very happy if I manage to work enough to earn my living, for it makes me very worried when I tell myself that I've done so many paintings and

drawings without ever selling any.

SP: Money worries you; you write of it often to Theo.

V: I'm always reproaching myself that my painting is not worth what it costs.

SP: And do these concerns make it harder to paint? I mean, would it be easier if your paintings were selling for thousands of francs? I know Gauguin has managed to sell some – well, quite a few in fact.

V: Perhaps the time will come when my work will put some money in my pocket, which I'm badly in need of. But although I place great value on money, the number one thing is to make something that's reasonable. Gauguin said nothing, among the variety of human ills, vexed him more than the lack of money – and yet he feels doomed to be broke forever.

SP: The struggling artist; perhaps even the paranoid artist!

V: Many are beginning to understand how ridiculous it is to make oneself dependent on the opinions of others about what one does.

SP: That seems wise.

V: Painting is faith and it imposes the duty to disregard public opinion. Paintings have a life of their own which derives from the painter's soul.

SP: And tell me – what is your response to the common accusation that you paint too fast?

v: Fortunately for me, I know well enough what I want, and am basically indifferent to criticism that I work too hurriedly. In answer to that, I have done some things even more hurriedly these last few days.

sp: Typical! Though as to your leaving of the Yellow House, perhaps you would have wished it less hurried? It was a sad time, going back for the last time. There had been a flood I believe, and floods are terrible things.

v: Not only the studio had come to grief, but even the studies that would have been reminders of it.

sp: That must have been hard.

v: It was all so final; and my urge to found something simple yet lasting, was so strong.

sp: But for some reason, the dream of the artistic community didn't work out.

v: I was fighting a losing battle; or rather, it was a weakness of character on my part, for I am left with feelings of remorse about it, difficult to describe.

sp: Did you feel a failure?

v: I think that was the reason I cried out so much during the attacks; I wanted to defend myself and I couldn't do it.

sp: No.

*I pause in the face of such wafer-thin vulnerability.*

And yet here you are today! You've survived; survived to paint. You've managed to keep on keeping on as they say, doing the small things right.

v: Great things are not done by impulse, but by a series of small things brought together.

sp: And if you yourself struggle to be proud of your work, then let me be proud for you. You are a painter!

*Vincent smiles.*

v: And those who can paint, those who can do it best, are the germs of something that will continue to exist for a long time; just as long as there are eyes to enjoy something that is singularly beautiful.

# Mental states

*One night in Arles – the night Gauguin left – Vincent cut off part of his left ear. He sliced it downwards with a razor, wrapped it up, and then delivered it to a prostitute called Rachel, who worked in his favourite brothel. After this, he returned home to sleep in a blood-soaked bed. Soon after, Vincent admitted himself to the asylum at St Rémy, and stayed there for six months. Dr Rey looked after him there.*

*He's come here to Auvers-sur-Oise straight from St Rémy. Part of his upper ear remains, as a strange flap, and he hunches his left shoulder as if to protect it. He is under the watchful eye of Dr Gachet, who, it turns out, is also an art lover, and a bit of a painter himself.*

*I'll try to talk about these things with Vincent. Though how much an aspiring artist will want to speak about it, I'm not sure. In the meantime, I'm wondering if it was the drink. Absinthe is the preferred shot of the poor, but currently also popular with a long list of writers and artists, attracted by its dark reputation. We must include Vincent in this list; though I must say, I see no sign of the stuff here, either in a bottle or on his breath.*

SP: You say you need to laugh. Is that instead of crying?

V: I can count so many years of my life when I lost all inclination to laugh – leaving aside whether or not this was my own fault – because I for one need above all to have a good laugh.

SP: And who makes you laugh?

v: Guy de Maupassant, Rabelais and Voltaire.

sp: So you need a good laugh. Do you also need a good woman?

v: For my part, I have continually had the most impossible and highly unsuitable love affairs from which, as a rule, I emerge only with shame and disgrace.

sp: Some would be put off by that experience.

v: No, in this I was absolutely right, because I felt that in my earlier years when I should have been in love, I immersed myself in religious and socialist affairs.

sp: So you had some catching up to do; and always the dream of a family and children.

v: I don't know if you've ever had that feeling which sometimes forces a sort of sigh or groan from one when one is alone: 'Oh God, where is my wife? Oh God, where is my child? Is being alone really living?'

sp: So your decision to leave Sien and the children must have been one of your hardest. In a way, they were your first and only experience of family.

v: It is the loneliness a painter has to bear – whom, by the way, everybody in isolated areas regards as a lunatic, a murderer or tramp. But there is no anguish greater than the soul's struggle between duty and love.

sp: And your duty was to painting?

v: It was a cup that would not pass away from me unless I drank it. So *fiat voluntas* – thy will be done!

sp: And from that time on, your commitment to painting was total.

v: Yes, I put my heart and soul into my work, and have lost my mind in the process. When loneliness, worries, vexations, the need for friendship and fellow-feeling are not met, that's very bad.

sp: And alcohol helps?

v: The mental emotions of sadness and disappointments undermine us more than riotous living; us, that is, who find ourselves the happy owners of troubled hearts! Anyway, to write a book, perform a deed or make a painting with life in it, one must be a living person oneself. Enjoy yourself too much rather than too little!

sp: So a man should do with his life whatever he wants? There are no rules.

v: The book *In Search of Happiness* by Tolstoy affected me very greatly. And does it not say there that evil lies in our own natures, which we didn't create ourselves? The moderns don't moralize like the old ones.

sp: So no one's responsible for who they are, and we should stop telling people what to do?

v: It seems gross to many people and they're angered by it. But vice and virtue are chemical products like sugar or vitriol.

sp: I don't think you believe that; your pictures are too full
of soul and longing for that sort of science. But watching
you work in Auvers these days, there is in you the frenzied
thrashing of a fish, caught and desperate. Do you feel you are
dying?

v: I don't feel I'm dying, but I feel the reality of the fact that
I'm not much; and that to be a link in the chain of artists, I
pay a steep price in health, youth and freedom which I don't
enjoy at all – anymore than the cart horse which pulls a
carriage full of people who, unlike him, are going to enjoy the
spring time. You suffer to see your youth going up in smoke,
but if it comes back in what you do –

sp: You mean, if the paintings are young?

v: – then there's nothing lost. The power to work is a second
youth.

sp: But I wonder – do you always look after yourself as best
you can?

v: A friend of mine asserted that the best treatment for all ills
is to treat them with the most profound contempt!

sp: You seem to take pleasure in treating yourself harshly;
though you tell Theo to have baths.

v: Of course! Relative health is necessary in order to be able
to work. And our only means of avoiding being finished too
soon is the artificial prolongation of modern hygiene
rigorously followed – as far as we can endure it.

sp: And when it comes to hygiene, I suspect you cannot

endure very much!

v: I for one don't do everything I should do, no. And a little good cheer is better than any other remedy.

sp: In your past, you've lived on absinthe – and coffee.

v: I drink large quantities of bad coffee not because this is very good for already bad teeth, but because my strong powers of imagination enable me to have a religious faith in the cheering effect of the fluid.

sp: The wonders of blind faith. But it seems you almost welcome mental instability, in order to create.

v: It's only too true that a lot of artists are mentally ill. It's a life which, to put it mildly, makes one an outsider. I'm alright when I completely immerse myself in work, but I'll always remain half-crazy.

sp: And is a half-crazy artist a good thing?

v: The times we live in are a great revival of art. The moth-eaten and official tradition, which is still on its feet, is at bottom powerless and bone-idle. The new painters are alone, poor, treated like madmen and as a result of this treatment, become so in fact, as far as their social life is concerned.

sp: So sanity must be sacrificed to art?

v: A painter ruins his character by working hard at painting, which makes him sterile for many things, for family etc; and as a consequence, he paints not only with paint but with self-abnegation and self-denial and a broken heart.

s p: And to repeat the question, this disintegration is the source of his – or your – creativity?

v: The more I become dissipated, ill, a broken pitcher – the more I become a creative artist. The green shoot growing from an old felled trunk! These things are so spiritual that a kind of melancholy remains with us, when we reflect that at less expense, we could have made life, instead of making art.

s p: But it's a price worth paying?

v: The fishermen know that the sea is dangerous and the storm terrible, but they have never found these dangers sufficient reason for staying ashore.

s p: No. But some painters still get shipwrecked, and give in.

v: True. One painter, Breitner, has become a teacher at a secondary school – although I know he wasn't looking forward to it.

s p: Perhaps he'll be surprised.

v: Another painter recently ended up in the madhouse; and now that he's inside everyone talks very sympathetically of him and calls him very clever!

s p: Then you must hope for the same luck, because of course you ended up in a 'madhouse', as you call it. You entered voluntarily after the 'ear' incident in Arles.

v: I wished to go to the mental hospital at St Rémy, yes. I felt decidedly incapable of taking on a new studio again and living there alone, with all the other responsibilities on my back. I

wished to be confined as much for my own tranquillity as that of others.

sp: And the asylum at St Rémy – it was a good place?

v: What consoled me was that I began to consider madness as an illness like any other, and accept the thing as it is – while during the actual crisis, it seemed to me that everything I was imagining was reality.

sp: And what were you imagining when you cut off your ear?

v: I don't want to think or talk about it. Isolated in the studio sometimes and without any other source of entertainment than to go to a café or a restaurant with all the criticism of neighbours – I can't do it!

sp: It's not a crime. We can only do what we can do.

v: But I am astonished.

sp: Astonished by what?

v: I am astonished that with the modern ideas that I have, and being so ardent an admirer of Zola and de Goncourt and caring for things of art as I do, that I have attacks such as a superstitious man might have.

sp: What sort of superstition?

v: I get perverted and frightful ideas about religion such as never came into my head in the north.

sp: And how do these attacks feel?

v: There are horrible fits of anxiety, apparently without cause; or otherwise a feeling of emptiness and fatigue in the head. I have had, in all, four great crises, during which I didn't in the least know what I said, what I wanted or what I did.

sp: And that night in Arles was one of those.

v: There were moments of indescribable mental anguish; sometimes moments when the veil of time and the fatality of circumstances seemed to be quite torn apart for an instant.

sp: Were such states peculiar to Arles and St Rémy?

v: No, I have been in a hole all my life, and my mental state is not only vague now, but has always been so; so that whatever is done for me, I cannot think things out so as to balance my life.

sp: You've always been a remarkable letter writer. Did writing help you bring balance – or at least lance the boil of some pent-up feeling?

v: I think that if I didn't give vent to my feelings once in a while, the boiler would burst.

sp: People do say that you aren't helped by your drinking habits.

v: That again! The doctor from St Rémy –

sp: Dr Rey?

v: He went to see Theo, and told him he didn't consider me a lunatic, but that the crises I had were of an epileptic nature.

So it wasn't alcohol which was the cause; though of course it didn't do one any good.

SP: I suppose everyone has their own opinion about your illness.

V: If alcohol was certainly one of the great causes of the madness, then it came very slowly and would go away slowly too. Or if it came from smoking, same thing.

SP: So why drink?

V: As I've said, if the storm within gets too loud, I take a glass too much to stun myself.

SP: Would life without alcohol and tobacco be possible?

V: Alcohol and tobacco have this good or bad point: that they are anti-aphrodisiacs! Not always to be despised in the exercise of the fine arts.

SP: They help keep you focused on the job in hand.

V: Virtue and sobriety, I'm only too afraid, would have led me again into those parts where I lose the compass completely, and where I must have less passion and more bonhomie.

SP: And the hospital itself? I've never visited an asylum.

V: They had a lot of room in the hospital – enough to make studios for 30 or so painters, as it's only too true that an awful lot of painters go mad.

SP: You think there should be a special asylum for painters?

v: It's a life which makes you very distracted. I throw myself into work again now, but I still remain cracked.

sp: You wish you could have stayed longer at St Rémy?

v: If I could have enlisted for five years. I would have recovered considerably and would be more rational and more the master of myself.

sp: And what of the other patients?

v: Although there were some who howled and raved occasionally, there was much true friendship for each other. So really, the company of other sick people wasn't at all disagreeable to me; on the contrary, it distracted me.

sp: And the food?

v: The ordinary food suited me, especially as I was given a little more wine than usual; half a litre instead of a quarter.

sp: I'm sure a settled diet helped, as you've had an odd relationship with food in your life.

v: Perhaps you will not understand but it was true that when I received money, my greatest appetite was not for food – the appetite for painting was stronger.

sp: So back in Brussels, Drenthe and Antwerp, you spent all your money on models. What did you eat?

v: All I had to live on was breakfast served by those I lived with, and in the evening for supper, a cup of coffee and some bread.

sp: Compared to which, the routine of St Rémy doesn't sound like an unpleasant experience.

v: In seeing the reality of the life of the diverse, mad or cracked people in the ménagerie, I lost the vague dread; the fear of the thing. The horror I had of madness before, greatly softened.

sp: Which must have been a relief.

v: In fact, never have I been so tranquil, as I was there and in the hospital in Arles.

sp: That's interesting to notice; in that holding routine, your melancholy and bitterness subsided.

v: I don't want to be included among the melancholy or those who turn sour and bitter and ill-tempered!

sp: No – but those attitudes can appear in you.

v: To understand everything is to forgive everything, and I believe if we knew everything we'd attain serenity – a better remedy for all ills than what is sold in the pharmacy.

sp: And in the meantime, you found beauty in St Rémy; even through barred windows.

v: Through the iron-barred window, I could make out a square of wheat where alone each morning, I saw the sun rise in glory. And the trees!

sp: Are you referring to *Cypresses* which you painted there? I was looking at it today.

v: The trees in that painting are very tall and massive. The foreground very low, brambles and undergrowth behind, violet hills, a green and pink sky with a crescent moon thickly impasted, tufts of bramble with yellow, violet green highlights.

sp: Wonderful. But tell me – was self-pity ever a danger during your confinement?

v: Not at all. It's only fair that having lived for years in relatively good health, sooner or later we have our share of illnesses. I wouldn't exactly have chosen madness if there had been a choice; but once one has something like that, then at least one can't catch it anymore!

sp: Dr Rey said that the 'over-excitement' of that night 'was only fleeting' and that you were quickly calm again. And your lucid letters from St Rémy support this. Whatever caused the crisis, it was very quickly over.

v: Oh yes, and I perhaps still have some almost ordinary years ahead of me. It's an illness like any other, and currently almost all those I know among my friends have something. It's just a matter of no longer causing scenes in public. I feel completely that I was in an unhealthy state, both mentally and physically; and people were kind to me then.

sp: And you were active with your painting at St Rémy. You produced many works, including 21 copies of Millet's works, which Theo says are the things you do best. It interests me: how do you go about painting after another painter?

v: If someone plays Beethoven, he adds his own personal interpretation. And when I was ill, I was trying to create something to comfort me, for my own pleasure. I'd put the

engraving by Delacroix or Millet in front of me, to use as a motif. And then I'd improvise colour, seeking echoes of their paintings; but the memory, the vague consonance of colours while at least correct in spirit, are my interpretation.

SP: So as ever, even in hospital, you were busy at work; and you felt that the other patients should have perhaps taken your lead?

V: My companions in misfortune quite often felt bored. There was a lot of resignation and patience there. But many of them did nothing, self-absorbed all day, and I think that if they'd been in an asylum where manual work was compulsory, they'd be better for it. Working fortifies the will, and allows the mental weaknesses less hold.

SP: But in the end, despite your evident health there, you began to tire of St Rémy.

V: They were very expensive, and I was afraid of the other patients. I felt a kind of fear. You'll tell me what I told myself, that the fault must be inside me and not in the circumstances or other people.

SP: I'm not telling you anything.

V: Anyway, it wasn't fun.

SP: So you left and travelled north to Auvers, where we now sit. And looking back, what do you feel about the crisis in Arles?

V: I regret causing trouble. I caused anxiety and if I'd been in a normal state, all of this wouldn't have happened in that way.

SP: But you feel better now?

V: As we advance through life it becomes more and more difficult, but in fighting the difficulties, the inmost strength of the heart is developed.

# *Heroes*

---

*Vincent van Gogh is an individualist really. This is my opinion anyway. He likes bright banter in a group; and until now, has always dreamed of an artistic community. But his life reveals that whatever group he is in, he remains somehow apart, always an individual, somehow not belonging. He says he likes relationships; but experience shows he tends to destroy them.*

*I do want to hear of his heroes, however; those he admires or who have influenced him. I believe our heroes – and what we see in them – say much about us.*

SP: You are a voracious painter; but also a voracious reader.

V: I am a man of passions, and I have a more or less irresistible passion for books and the constant desire to improve myself, to study, if you like; just as I have a need to eat bread.

SP: In fact it was writers rather than painters who were your earliest influences. Who stood out for you in those formative days?

V: I considered Thomas Carlyle and George Eliot to stand at the forefront of modern civilization. My strongest sympathies in the literary as well as the artistic field were with those artists in whom I could see the soul at work most strongly. This 'something different' is pronounced in Eliot, and Dickens has it as well.

SP: Is it the subject matter?

v: No, for that is only an effect.

s p: So it's not the subject itself, but about how it is handled?

v: Indeed. What I am driving at is that while Eliot is masterly in her execution, above and beyond that, she also has a genius all of her own.

s p: And we've talked already of Dickens.

v: There is no writer, in my opinion, who is so much a painter and a black-and-white artist as Dickens. His figures are resurrections.

s p: But also a man who possessed a quality of sadness.

v: Sadness? Dickens had it, yes: 'the man of sorrows and acquainted with grief.' I once saw a portrait of him that I won't forget – strange, and one would say, savage, in which he was sitting on a chair by a fire, as though watching someone.

s p: And you were inspired by another writer, Michelet.

v: Father Michelet I call him!

s p: So what do you admire in him?

v: Michelet feels strongly and he smears what he feels onto paper without caring in the least how he does it, and without giving the slightest thought to technical or conventional forms.

s p: Rather like you, in fact! And still with writers, Theo gave me an interesting piece of information. He said that in your letters to him, Zola is the writer you mention the most.

v: The work of the French naturalists, Zola, Flaubert, Guy de Maupassant, de Goncourt is magnificent. They are portraying life as we feel it, thus satisfying the need we have to be told the truth.

sp: And Zola is a particular hero?

v: Yes, I told Theo to read as much Zola as he could; that it was good for one and makes things clear. I have just re-read his *The Ladies' Delight* and it seems to me more beautiful than ever.

sp: Zola mirrors your social conscience, and in one of your paintings, you pay him a big compliment. Here it is – your still-life called *Open Bible*. And what I see placed next to the holy book – smaller but in the forefront – is Zola's *The Joy of Living*. Even if there isn't much joy in it.

v: What touches me most deeply in Zola's work is the figure of Bongrand-Jundt. What he says is so true. You imagine, you poor souls, that when an artist has established his talent and his reputation, he is safe.

sp: Sounds reasonable.

v: On the contrary, it is now denied him henceforth to produce anything which is not absolute!

sp: You mean, once you are famous, nothing speculative or experimental is permitted from then on?

v: His reputation forces him to take more pains over his work. At the least sign of weakness, the whole jealous pack will fall on him and destroy that very reputation and the trust that the

changeable and faithless public had in him.

SP: And that thought frightens you, I can see. Though of course, your reading habits have changed. At one time you read only the Bible, and declared that to be the only literature necessary.

V: Is the Bible enough for us? In these days, I believe Jesus himself would say to those who sit down in a state of melancholy – 'it is not here, get up and go forth. Why do you seek the living among the dead?'

SP: You believe new scriptures are being written. But moving on from literature, which painters have impressed?

V: Just as the French are undeniably masters in literature, so it is in painting too. Delacroix, Millet, Corot, Courbet and Daumier dominate everything that has been produced in other countries.

SP: Theo says that Millet is mentioned 200 times in your letters. He, above all others, was your role model.

V: Millet – who had hardly any colour – what work is his!

SP: You never met him; but in his painting, he honoured peasants and farmers, and this resonated with you. 'I was born a peasant and shall die a peasant!' he said.

V: I call him Father Millet – that is, a guide and counsellor in all things for the younger painters. For me, it is not Manet but Millet who was the essentially modern painter who has opened the horizons for many others.

s p: And other inspirational painters?

v: Oh, to paint figures like Claude Monet paints landscapes! That's what remains to be done, despite everything. And I remember a magnificent garden of roses by Renoir.

s p: And changing direction somewhat in our list of heroes, even while I've been here, you have often mentioned Roulin.

v: Joseph Roulin!

s p: He was the postmaster in Arles; so a different sort of hero for you. Not an artistic type; but he and his family were perhaps your only friends in Arles.

v: All characters and very French – though Joseph looked more Russian.

s p: And what was his particular virtue?

v: I have rarely seen a man of Roulin's fortitude.

s p: Was he perhaps a father figure to you?

v: There was in him something tremendously like Socrates. Ugly as a satyr, but such a good soul; and so wise and so full of feeling and so trustful. He had a tenderness for me such as an old soldier might have for a younger one.

s p: You drank together.

v: We did, but he was the reverse of a sot. His exaltation was so natural, so intelligent and he argued with such a sweep, in the style of Garibaldi.

SP: So a good man with a good family – who appeared in no less than 25 paintings and sketches of yours! And finally, someone you haven't met, but have painted. I found amongst your book collection Renan's *Life of Christ*.

V: Isn't Renan's Christ a thousand times more comforting than so many *papier mâché* Christs that they serve up in the protestant, catholic or something-or-other churches?

SP: Some say Renan just offers the emotion of religion without the substance, but you do find substance in Jesus. In both your painting and reading, the figure of Christ returns again and again – if only as Christ-like figures like Jean Valjean in Hugo's *Les Misérables*. So who is Christ for you, Vincent? Is he still one of your heroes?

V: Christ alone, of all the philosophers, magi etc, has affirmed as a principal certainty: eternal life, the infinity of time, the nothingness of death, and the necessity and reason for serenity and devotion.

SP: Quite a legacy.

V: He lived serenely, as a greater artist than all the other artists, despising marble and clay, as well as colour, working in living flesh.

SP: Christ the human artist?

V: That is to say, this matchless artist, hardly to be conceived of by the obtuse instrument of our modern nervous stupefied brains, made neither statues nor pictures nor books; he loudly proclaimed that he made living men – immortals!

# Nearly famous

*Dr. Paul Gachet is both doctor and friend to Vincent here in Auvers-sur-Oise. But things have changed between him and Theo, who now has a wife and child to look after. I wonder if Vincent feels marginalized by this, because until now, Theo has always looked after him. The old partnership is creaking and maybe Vincent is the more hurt.*

*I also wonder if he isn't a bit jealous of Theo. His parents clearly preferred the younger son, and it does surprise me that Vincent, who has always been desperate for models, has never painted Theo. After all, Theo's monthly cheques have kept Vincent alive.*

*But then, perhaps he didn't wish to grant him that immortality. One immortal brother is enough.*

SP: Two years ago, your first art teacher Anton Mauve died suddenly of an aneurysm at the age of 49. How did that affect you?

V: It affected me very badly. I loved him as a human being.

SP: In memory, you sent a painting of a pink peach tree in blossom. Interesting choice.

V: It seemed everything in memory of Mauve should be at once tender and very gay; and not a study in a darker key:

> 'Oh never think the dead are dead;
> so long as there are men alive;
> the dead will live, the dead will live!'

That is how I felt about it.

s p : But still you were hurt by the loss.

v : I find it so hard to imagine that those who penetrate
to the heart of life – who deal with others with as little
embarrassment as if they were dealing with themselves – I find
it so hard to imagine that such people cease to exist.

s p : Perhaps they don't; perhaps Anton lives on.

v : I have little faith in the rightness of our human ideas
concerning our future life.

s p : Is religion entirely gone inside you?

v : Not at all, not at all. I have a terrible need for – I will use
the word – religion, so I go out at night and paint the stars.

s p : And of course perhaps fame is round the corner at last?
The much-praised critic Albert Aurier recently devoted a whole
article to you, using very favourable tones. He called you 'a
sower of truth who will regenerate our decadent and perhaps
imbecilic industrial society'. Quite an accolade! And he noted
your passion for 'the solar disc' and praised your 'vegetal
star, the sumptuous sunflower, and the brilliant and dazzling
symphonies of colour.' Such applause must be encouraging?

v : Aurier's article would encourage me if I dared let myself go,
and venture even further, dropping reality and making a kind
of music of tones with colour.

s p : But you don't want to drop reality. Why not?

v: It is so dear to me, this truth, this trying to make it true, that I would still rather be a shoemaker than a musician in colours.

sp: I see.

v: And such an approach is perhaps also a remedy in fighting the disease which still continues to disquiet me.

sp: You mean that psychologically, form is better for you than abstraction – a chair, a sunflower, an old man; something specific and focusing.

v: I think so. But I was very grateful for the article, or rather, 'glad at heart', since one can need it as one can truly need a medal.

sp: Then consider a medal pressed firmly on your chest, Vincent! And would you like fame? I sense mixed feelings.

v: Fame is ramming the live end of your cigar in your mouth.

sp: So not *that* mixed.

v: Let me quote Carlyle: 'You know the glow worms in Brazil that shine so, that in the evening the ladies stick them into their hair with pins; well, fame is a fine thing, but look you: to the artist it is what the hairpin is to the insects.'

sp: Yet what I like is this, Vincent: no one saw you coming. You've developed into fully fledged artist in less than ten years, only really getting into your stride when you left Paris in 1888 and travelled south to Arles. And no one saw it; not until Aurier. Yet here you are on the edge of fame; nearly famous!

v: I can't count on living a great many years, but yes, I have an obligation and duty to leave a certain souvenir in the form of drawings and paintings in gratitude.

sp: But surely you *can* count on living a great many years? You are young!

v: People pay a lot for the work when the painter himself is dead. And people always disparage living painters by pointing unanswerably to the work of those who are no longer with us.

sp: True. But is there any way you can change that?

v: We can't do anything to change this. For the sake of peace, one must therefore resign oneself to it, or have some sort of patronage or captivate a rich woman. Everything one hopes for in terms of independence through one's work – of influence on others – absolutely nothing comes of it.

sp: Strange, but I was thinking about death when rooting about yesterday – and suddenly found myself holding your picture of a corpse! It was a bit of a shock, but as I looked, it was actually rather peaceful, and suggested to me that you don't fear death.

v: Just as we take the train to Tarascon or Rouen, we take death to reach a star. Death holds no terror for me. Indeed, I remember the corpse of a dead uncle.

sp: What struck you?

v: Why was the face of the deceased calm, peaceful and grave – when it's a fact he was rarely that way while living, either in youth or age?! And I have often observed a similar effect as I

looked on the dead, as though to question them. Clearly there is life beyond the grave –

SP: – oh, I thought –

V: – so as I say, illness and death hold no terrors for me.

SP: And Theo? You wanted him to be an artist, of course. What happened to that idea?

V: Office life mechanized Theo; a more artistic intelligence became somewhat sterilized.

SP: But in the meantime, he's been your strong pillar, and a constant reassurance. You once wrote to him, concerned at the drain you were on his resources. And I love his reply: 'I want to tell you something once and for all, Vincent. I look upon it all as though the question of money and the sale of pictures and the whole financial side did not exist.' I thought that was very kind.

V: Yes, my life depends on his help.

SP: And if he now has to lessen that help, due to family commitments?

V: That would be like choking or drowning me.

SP: You feel removed from the inner circle of his care, perhaps; cast out into the cold?

V: He is quite the plush gentleman, and I the black sheep!

SP: You feel lonely and worthless again.

v: Long ago, I remember accompanying a friend to the station in Amsterdam. I got up early and saw the workers arriving at the dockyard with the sun shining wonderfully. The curious sight of that stream of black figures, first in the narrow street into which the sun shines only briefly; and later at the yard.

sp: And your point?

v: I had breakfast afterwards, a piece of dry bread and a glass of beer – that is a remedy Dickens recommends to those on the verge of suicide, as being very efficacious in ridding them of that intention for a while at least. And even if one isn't exactly in such a mood, it's nevertheless good to do it now and again, and to think at the same time of, for example, Rembrandt's painting of the supper at Emmaus.

sp: At which the resurrected Christ sits and eats. So you'll carry on?

v: Auvers is decidedly very beautiful. I can do nothing about my illness.

sp: And your work?

v: I do not say my work is good, but the thing is that I can do less bad stuff. Everything else, relations with people, is very secondary, because I haven't got the gift for that. I can't help that.

sp: You're playing to your strengths; but you're tired.

v: There may be times in one's life when one is tired of everything, feeling that all one does is wrong; and there may be some truth in it. Do you think this is a feeling one

must try to forget and banish?

sp: Yes I do.

v: Or is the longing for God – which one must not fear, but cherish – to see if I may bring some good?

sp: It seems to me that has always been your longing.

v: And is it also 'the longing for God' which leads us to make a choice we may never forget?

sp: What sort of choice?

*Vincent relights his pipe.*

v: For now, though, I want to be somebody in my time. Yes, to be active, so that when I die I can think: I go where all those who were daring go. So no turning back, old chap!

sp: No turning back, Vincent; no turning back.

# *Afterword*

I write this many years later, never having published my interview. But here are the facts:

Vincent van Gogh shot himself with a revolver on Sunday afternoon, 27 July 1890. He did this in a field where he was painting and then staggered back to the lodgings where we'd met. There, Dr Gachet treated him, and it seems that Vincent was not in great pain. His mind appeared clear, and he was smoking his pipe.

He did have an interesting conversation with the police, who came along the next day, to express their disapproval of his behaviour:

GENDARME: Are you the one who wanted to commit suicide?

V: Yes, I believe.

GENDARME: You know that you do not have the right?

V: Gendarme, my body is mine and I am free to do what I want with it. Do not accuse anybody – it is I that wished to commit suicide.

Apparently, he refused to give Theo's home address to Dr Gachet, but the Doctor managed to get the message to him anyway, and Theo reached Vincent before he died. 'Do not cry,' said Vincent to his younger brother. 'I did it for everybody.' He died in Theo's arms at 1.00am, Tuesday morning, 29 July aged 37.

As it turned out, Theo did not have long to live either. He contracted syphilis, and seemed unable to handle Vincent's

absence. He had a weak heart, suffered a stroke and passed into a coma, dying on 25 January, six months later. In 1914, his body was exhumed and buried next to that of Vincent, in Auvers-sur-Oise.

They say the offspring of Vincent van Gogh is Expressionism, but I don't much favour labels. Rather, I think of his pictures, each ripped wonderfully from his soul, now dancing and passionate in the world, like children in a playground.

Of course, I now see things I didn't see when we met. I see a self-conscious masochist, who forever felt ugly and repulsive. I see a guilt-ridden man, who felt he deserved nothing but punishment. I see a stranger on earth who never quite belonged; never quite came home – but set off such fireworks along the way!

Vincent mentioned suicide frequently, but almost always to condemn it. He agreed with his hero Millet who said that suicide was the act of a dishonest man, and no one saw it coming. I spoke with a member of his landlady's family, and she said this: 'He had a very penetrating glance, gentle and calm, but not a very communicative character. When one spoke to him, he always replied with an agreeable smile. He spoke French very correctly, searching a bit for his words. He never drank alcohol. The day of his suicide he was not in the least intoxicated as some claim. When I later learned he'd been interned in an asylum for lunatics in the Midi, I was very surprised, as he always appeared gentle and calm in Auvers.'

And he himself had said to me: 'I feel much calmer than last year, and really the restlessness in my head has greatly quietened down.'

Theo, however, said his last words were: 'The sadness will last forever.'

As for his funeral, Émile Bernard attended, and wrote of it to Albert Aurier, the critic who was the first to see Vincent coming:

'Our dear friend Vincent has been dead about four days,' wrote Émile. 'He filed his easel against a hay stack and fired a revolver behind the castle. He died explaining his suicide was absolutely calculated and wanted very clearly. When Dr Gachet said he hoped to save his life, Vincent said: 'Then I'll have to do it all over again.'

On the walls of the funeral parlour were many of his paintings. On a simple bier, there was a white sheet, and a quantity of yellow roses.

'It was his favourite colour, if you remember,' writes Émile. 'The symbol of light he dreamed in our hearts, as in the works.'

Laid out in front of his coffin were his easel, folding stool and brushes. Many people came, mostly artists, including Pissarro. Theo apparently 'sobbed painfully', while Dr Gachet tried to speak, but was crying too much himself to manage anything very coherent. 'But perhaps that was the most beautiful way of doing it,' says Émile.

The sun was very hot outside, in his honour; after all, who painted the orb like Vincent? And Dr Gachet, when he was able to speak, said Vincent had only two aims: 'humanity and art.'

Pissarro wrote to Theo: 'I really felt a great affinity to your brother who had the spirit of an artist.'

Toulouse-Lautrec was very sad to miss the funeral: 'You know what a friend he was to me and how eager he was to demonstrate his affection.'

And my memories of the man? Sorrowful yet always rejoicing! It was a phrase he used often when we talked; and it echoes now in my mind as his paintings find fame and scatter round the world; the same paintings I remember at Auvers, stacked unwanted against the wall. I'm sorrowful but rejoicing. Sorrowful at his tortured life; rejoicing at what he created from

it. And wishing – wishing he himself had heard the applause in the deep places of his soul. Perhaps he can.

So a handshake in thought, Vincent! That's how he always finished his letters to Theo. A handshake in thought! And if heaven is where the daring go, as you say, then you are deep in its glory and adventure now.

# Simon Parke

Simon Parke was a priest in the Church of England for twenty years, before leaving for fresh adventures. He worked for three years in a supermarket, stacking shelves and working on the till. He was also chair of the shop union. He has since left to go free lance, and now writes, leads retreats and offers consultancy.

He has written for *The Independent* and *The Evening Standard*, and is currently columnist with the *Daily Mail*. His weekly supermarket diary, 'Shelf Life', ran for 15 months in the *Mail on Saturday*, and he now contributes another weekly column called 'One-Minute Mystic.' The book version of *Shelf Life* has recently been published by Rider. The book version of *One-Minute Mystic* is published by Hay House.

Other books by Simon include *Forsaking the Family* – a refreshingly real look at family life. Our families made us; yet we understand very little of how our experiences as children still affects us. The book starts by contemplating Jesus' ambivalence towards his own family, particularly his parents; reflects on how our family settings can both help and harm us; and suggests paths for freedom and authenticity.

*The Beautiful Life – ten new commandments because life could be better* was published by Bloomsbury, and describes ten skilful attitudes for life. Simon leads retreats around this book, and talks about it on this site. It is now also available in audio form with White Crow books.

Simon has been a teacher of the Enneagram for twenty years. The enneagram is an ancient and remarkable path of self-understanding, and Simon's book on the subject, published by Lion, is called *Enneagram – a private session with the world's greatest psychologist*.

*Another bloody retreat* is Simon's desert novel, describing events at the monastery of St James-the-Less set in the sands of

Middle Egypt. It follows the fortunes of Abbot Peter and the rest of the community, when the stillness of their sacred setting is rudely and irrevocably shattered.

Simon was born in Sussex, but has lived and worked in London for twenty-five years. He has written comedy and satire for TV and radio, picking up a Sony radio award. He has two grown-up children and his hobbies include football, history and running. For more information, visit his website www.simonparke.com

# Also available from White Crow Books

Marcus Aurelius—*The Meditations*
ISBN 978-1-907355-20-2

Elsa Barker—*Letters from a Living Dead Man*
ISBN 978-1-907355-83-7

Elsa Barker—*War Letters from the Living Dead Man*
ISBN 978-1-907355-85-1

Elsa Barker—*Last Letters from the Living Dead Man*
ISBN 978-1-907355-87-5

Richard Maurice Bucke—*Cosmic Consciousness*
ISBN 978-1-907355-10-3

G. K. Chesterton—*The Everlasting Man*
ISBN 978-1-907355-03-5

G. K. Chesterton—*Heretics*
ISBN 978-1-907355-02-8

G. K. Chesterton—*Orthodoxy*
ISBN 978-1-907355-01-1

Arthur Conan Doyle—*The Edge of the Unknown*
ISBN 978-1-907355-14-1

Arthur Conan Doyle—*The New Revelation*
ISBN 978-1-907355-12-7

Arthur Conan Doyle—*The Vital Message*
ISBN 978-1-907355-13-4

Arthur Conan Doyle with Simon Parke—*Conversations with Arthur Conan Doyle*
ISBN 978-1-907355-80-6

Leon Denis with Arthur Conan Doyle—*The Mystery of Joan of Arc*
ISBN 978-1-907355-17-2

The Earl of Dunraven—*Experiences in Spiritualism with D. D. Home*
ISBN 978-1-907355-93-6

Meister Eckhart with Simon Parke—*Conversations with Meister Eckhart*
ISBN 978-1-907355-18-9

Kahlil Gibran—*The Forerunner*
ISBN 978-1-907355-06-6

Kahlil Gibran—*The Madman*
ISBN 978-1-907355-05-9

Kahlil Gibran—*The Prophet*
ISBN 978-1-907355-04-2

Kahlil Gibran—*Sand and Foam*
ISBN 978-1-907355-07-3

Kahlil Gibran—*Jesus the Son of Man*
ISBN 978-1-907355-08-0

Kahlil Gibran—*Spiritual World*
ISBN 978-1-907355-09-7

Hermann Hesse—*Siddhartha*
ISBN 978-1-907355-31-8

D. D. Home—*Incidents in my Life Part 1*
ISBN 978-1-907355-15-8

Mme. Dunglas Home; edited, with an Introduction, by Sir Arthur Conan Doyle—*D. D. Home: His Life and Mission*
ISBN 978-1-907355-16-5

Edward C. Randall—*Frontiers of the Afterlife*
ISBN 978-1-907355-30-1

Lucius Annaeus Seneca—*On Benefits*
ISBN 978-1-907355-19-6

Rebecca Ruter Springer—*Intra Muros—My Dream of Heaven*
ISBN 978-1-907355-11-0

W. T. Stead—*After Death* or *Letters from Julia: A Personal Narrative*
ISBN 978-1-907355-89-9

Leo Tolstoy, edited by Simon Parke—*Tolstoy's Forbidden Words*
ISBN 978-1-907355-00-4

Leo Tolstoy—*A Confession*
ISBN 978-1-907355-24-0

Leo Tolstoy—*The Gospel in Brief*
ISBN 978-1-907355-22-6

Leo Tolstoy—*The Kingdom of God is Within You*
ISBN 978-1-907355-27-1

Leo Tolstoy—*My Religion: What I Believe*
ISBN 978-1-907355-23-3

Leo Tolstoy—*On Life*
ISBN 978-1-907355-91-2

Leo Tolstoy—*Twenty-three Tales*
ISBN 978-1-907355-29-5

Leo Tolstoy—*What is Religion and other writings*
ISBN 978-1-907355-28-8

Leo Tolstoy—*Work While Ye Have the Light*
ISBN 978-1-907355-26-4

Leo Tolstoy with Simon Parke—*Conversations with Tolstoy*
ISBN 978-1-907355-25-7

Howard Williams with an Introduction by Leo Tolstoy—*The Ethics of Diet: An Anthology of Vegetarian Thought*
ISBN 978-1-907355-21-9

**All titles available as eBooks, and select titles available in Audiobook format from www.whitecrowbooks.com**

www.ingramcontent.com/pod-product-compliance
Lightning Source LLC
Chambersburg PA
CBHW030745200526
45160CB00010B/34/J